PERSPECTIVE

A Guide for Artists, Architects and Designers

GWEN WHITE

B T BATSFORD LTD LONDON

First published 1968
Second impression 1969
Third impression 1974
Fourth impression 1976
New edition 1982
Second impression 1987
ISBN 0 7134 3412 0

*Written and illustrated by the
same author*

Ancient and Modern Dolls
Toys' Adventures at the Zoo
Ladybird, Ladybird
A Book of Toys
Eight Little Frogs
A Book of Dolls
A Book of Pictorial Perspective
A World of Pattern
Dolls of the World
European and American Dolls
Antique Toys and their Background
Toys, Dolls and Automata, Marks and Labels

Printed by the Anchor Brendon Ltd, Tiptree, Essex
for the publishers
B T Batsford Ltd
4 Fitzhardinge Street, London W1H 0AH

FOREWORD

The most difficult part about Perspective is putting into words what one has drawn with a pencil.

Perhaps my explanations appear long, but they are easily understood if you follow each diagram while reading them. The Spectator is *you*, and when the Spectator appears on a diagram, I am behind him for the front views, and at the side for the side views.

Picture everything in the third-dimension, and *never join* this point to that point, or this line to that line. But take a point back, or bring a line forward as the case may be; in fact you will find that the word "join" has not been used.

This book is intended for the serious student, and here may be found the knowledge which lay behind my book on "Pictorial Perspective". This has been described as "whetting the appetite" and a "lively introduction to the subject". Again I have used my "lift-up" idea on many of the pages because naturally I could not eliminate the lines which lead to the finished drawing.

Blocks can turn into machines or fairy castles, rooms can be furnished in any period, unbuilt houses visualized as finished, and bare plots transformed into exotic gardens.

High buildings casting shadows over their lower neighbours should interest all would-be town planners, and the placing of objects to their best advantage makes a drawing superior to a photograph. It is most satisfying after making an outdoor sketch to test it at home with a piece of cotton, and find that the Vanishing Points actually work, and that the whole thing is true.

One last word – I hope you will enjoy the book as much as I have enjoyed making it, for Perspective, or if you prefer it 3 D, is quite an exciting thing.

ABBREVIATIONS

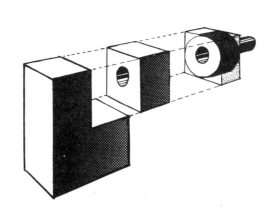

CONTENTS

NOTE

The illustrations and text on the following pages are arranged in a sequence that should be studied in columns and not across the page.

Pages marked 'a lift-up page' have a Perspective drawing on one side and the construction lines on the other. The two can be seen simultaneously by holding the page towards the light.

In this edition the measurements are given in feet and inches as well as in centimetres. Choose which you prefer but use the same throughout.

This book uses the approximation that one foot is equivalent to thirty centimetres.

PARALLEL PERSPECTIVE
THE GROUND PLANE

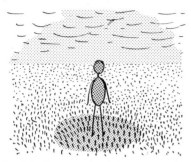

Imagine that when you are standing on the ground, that the small piece which you are on, is part of a big flat plane which has no ending, and is flat as far away as you can see. This flat plane will be known as the GROUND PLANE.

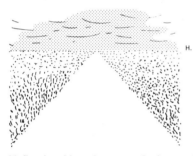

On this flat plane I have drawn a road, a long straight road which goes right away into the far distance, and appears to get narrower and narrower until it disappears where the land meets the sky, known as the HORIZON.

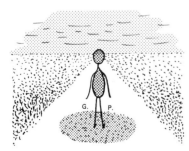

Now, if I put you back on your little piece of land, you would be here like this.

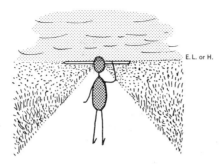

Supposing that you looked at the flattest, longest, straightest road you could find, and that you held up a pencil in front of your face, level with your eyes, you would see that the pencil exactly covered up the distant horizon. You would discover that the horizon was on a level with your eyes, and that it coincided with your EYE-LEVEL.

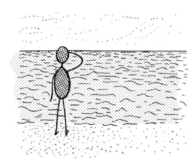

The same thing would happen if you were by the sea. You would find that the distant horizon was exactly on your eye-level, so that a tall person would see more of the water than a short one would.

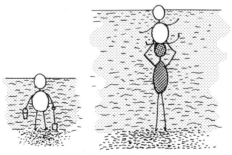

A small child would see less than a grown-up, and he would see more if you lifted him up. You would see more than ever if you walked up the cliff.

So this plane known as the Ground Plane, runs right away into the distance towards the Horizon, and in this diagram it is the sea.

But it could be the top of a table like this, which also is in a flat plane, and the sides appear to get closer together in the same manner as the road.

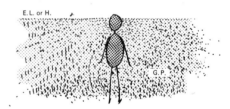

Therefore although we know that the Ground Plane is a piece of land like this –

H.

GROUND PLANE

we shall leave it absolutely blank like this.

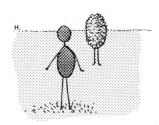

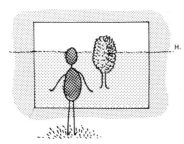

Imagine that every time you look at something, that between you and the scene, there is a sheet of glass in a vertical plane. It could be a window or a large sheet of transparent paper.

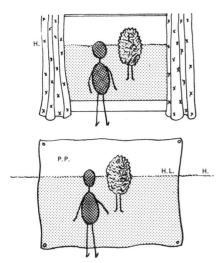

This imaginary vertical plane is known as the PICTURE PLANE, and what appears on this plane is what you will draw on your paper.

When the horizon is drawn on this plane it will be known as the HORIZON LINE, i.e. the H.L. The H.L. will cover up the H. beyond.

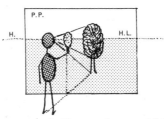

Suppose you are looking out of a ground-floor window at a tree. Stretch out your arm and draw the tree on the glass with a piece of chalk. This is actually drawing on the Picture Plane and it is amazing how small the tree will appear on the glass, especially if you stand near the window.

It is better to shut one eye while you are doing this.

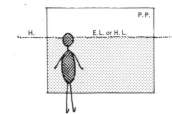

This diagram, drawn from the side, shows you with the piece of chalk, the sheet of glass, the distance, and the tree. The lines are drawn from the spectator's eye to the tree, and where they go through the sheet of glass the drawing of the tree has been made. This shows how small it appears to the spectator.

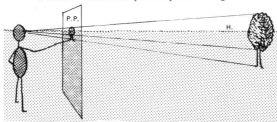

Now, omitting the tree, the diagram will appear like this from behind, first showing you with the sheet of glass –

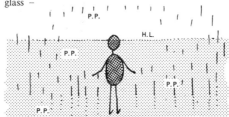

and secondly without the pane, because this imaginary plane has no limit, except that it is vertical with the ground and continues upwards, sideways, and even downwards.

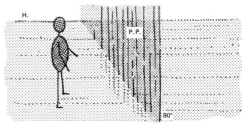

Being a vertical plane, it means that it will make right-angles with the Ground Plane, and the two together will look like this from the side,

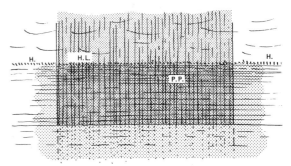

and like this from the front,

PICTURE PLANE

but we shall leave it blank in order that we may draw upon it.

THE PICTURE PLANE AND THE GROUND PLANE

Having visualized the Ground Plane and the Picture Plane we must now draw the two planes on the same diagram.

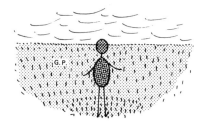

Here is your Ground Plane, which is horizontal.

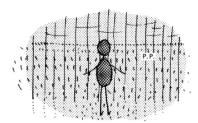

Here is your Picture Plane, which is vertical.

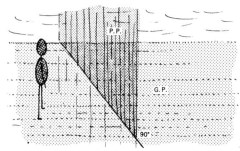

A side view of the two together will look like this. It will be seen that the G.P. and the P.P. are at right-angles to one another.

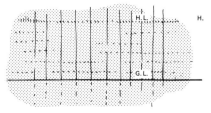

From the front the diagram will look like this, and where the two planes meet, it will be known as the GROUND LINE.

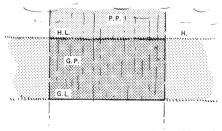

We now have the G.P. which is the Ground Plane, the P.P. which is the Picture Plane, the H. for the Horizon, the H.L. for the Horizon Line which is the Horizon drawn on the P.P. and the G.L. for where the two planes meet.

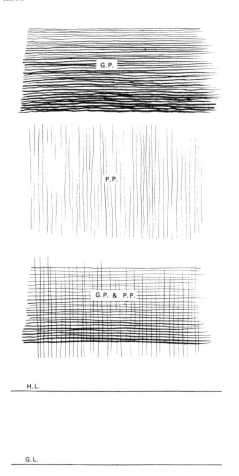

Leaving out all shading we have a blank diagram like this.

DISTANCE OF SPECTATOR FROM PICTURE PLANE

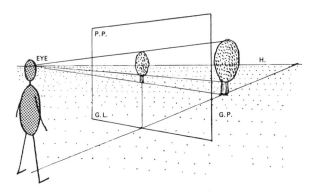

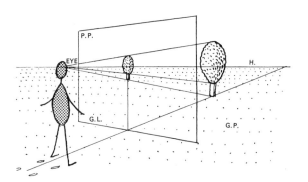

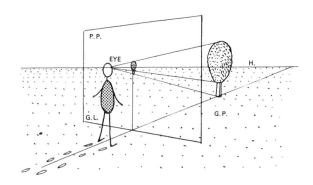

Perhaps it was noticed that when drawing on the window with the piece of chalk, that the nearer one stood to the window, the smaller the representation of an object became. The three diagrams above show this but it is far better to draw again on a window and try it out for oneself.

DISTANCE OF PICTURE PLANE FROM OBJECT

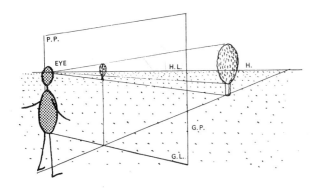

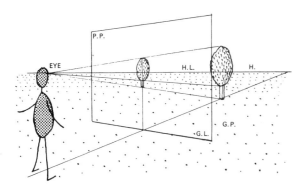

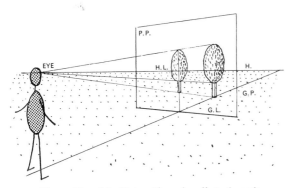

The position of the Picture Plane also affects the scale of an object.

From the diagrams above, it can be seen that the nearer the plane to the object, the larger the representation will be. In fact if the plane touched the object, the object would naturally be life-size. Therefore when deciding the scale of your drawing, two things must be considered: 1. The distance of the spectator from the Picture Plane. 2. The distance of the Picture Plane from the object.

THE CENTRE OF VISION AND THE EYE

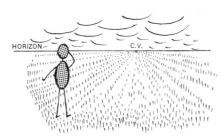

The point on the Horizon at which you are looking is known as the CENTRE OF VISION.

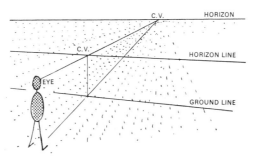

This point can be drawn on the Picture Plane. It will come on the Horizon Line and will cover up the Centre of Vision on the real Horizon beyond.

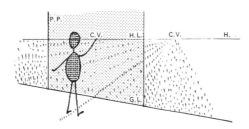

Perhaps it is easier to understand when drawn from a higher view-point.

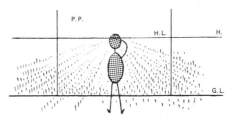

From the front it will look like this.

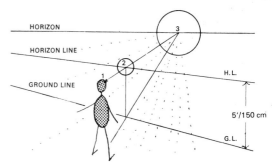

We now have three points
1. The EYE
2. The C.V. on the H.L.
3. The C.V. on the H.

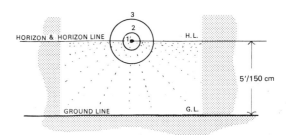

The diagram appears like this from the front, and without the circles it will look like the diagram below.

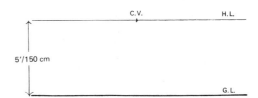

Thus we have one dot representing three points. Because the diagram now shows the height of the Eye only and not its distance from the Picture Plane, somehow we must show it in another way and this is done by having a separate point for the Eye on the Picture Plane.

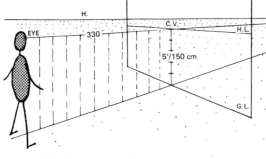

This diagram drawn from the side shows the Eye of the spectator 150 cm (5 ft) above the Ground Plane and 330 cm (11 ft) in front of the Picture Plane, measured from the C.V. to the eye.

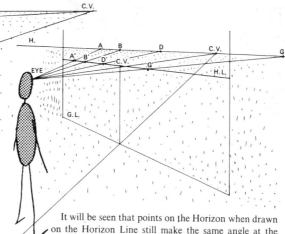

It will be seen that points on the Horizon when drawn on the Horizon Line still make the same angle at the Eye.

Just as the C.V. on the P.P. came in front of the C.V. on the Horizon, so the drawing of these points will also come in front of the real ones when seen from the spectator's view-point.

The reason we are going to so much trouble to get point E. on the Picture Plane is because we shall use this point to measure directional angles with a protractor.

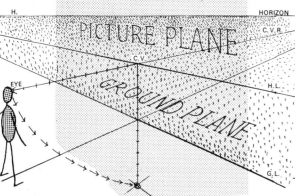

The line drawn from the Eye to the C.V. on the Horizon is known as the CENTRAL VISUAL RAY. It cuts the H.L. on the P.P. at the C.V.

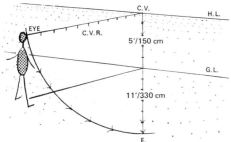

With the C.V. as a centre and the distance to the Eye as a radius, imagine an arc is made to meet a line drawn vertically down the Picture Plane from the C.V. This new point E. will represent the Eye.

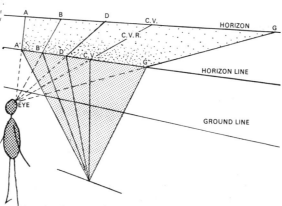

Another way of putting point E. on the Picture Plane would be to use the H.L. as a hinge and double down the line to point E. These lines instead of coming straight towards you, will now be on the Picture Plane.

The view from the side will look like this,

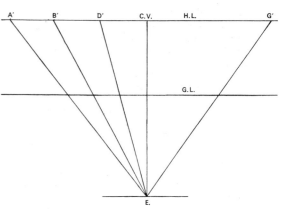

and from the front like this. The point to represent the Eye will be marked with an E.

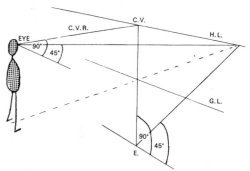

The diagram shows the new position of E. with an arbitrary angle of 45° marked at it. Note the angles in this diagram drawn from the side are shown in perspective and cannot be measured with a protractor, but when viewed from the front, they are actually 90° and 45° respectively.

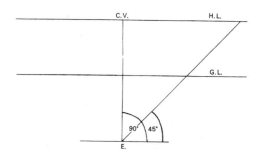

Leaving out all shading, the Picture Plane from the front will look like this and we have now reached the basic diagram on which perspective drawings will be made.

VANISHING POINTS

Lines receding into the distance appear to get nearer and nearer together until they finally merge into one point. This does not often happen in real scenes, perhaps on a long Roman road or between railway lines, but all real short lines are part of long imaginary lines, and these short lines also tend to get nearer together as they go away from the spectator.

Where lines parallel to one another appear to converge on the horizon, the point at which this happens is known as a VANISHING POINT.

All lines parallel to one another and receding from the spectator will have their own 'vanishing' point on the horizon, and these points can be marked on the Picture Plane in the same way as the Centre of Vision was marked.

Actually the C.V. acts as a vanishing point for all lines receding directly away at right-angles with the Picture Plane.

Often the vanishing points are concealed behind buildings or other hazards, but nevertheless they can still be found and drawn on the Picture Plane.

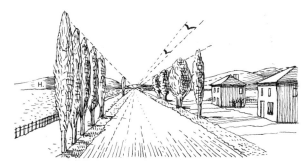

This drawing shows a long straight road with the sides appearing to meet at a point on the horizon.

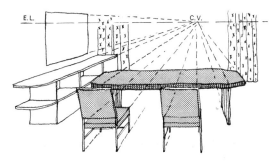

An interior made up of short lines which appear to meet on the Eye-level.

A street with the distant Vanishing Point hidden by buildings.

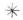

POINTS TOUCHING THE PICTURE PLANE
Examples

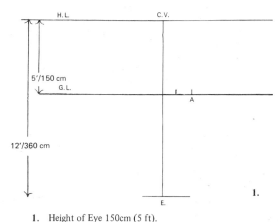

1. Height of Eye 150 cm (5 ft).
Distance from Picture Plane 360 cm (12 ft).
To find point A which touches the Ground Line at a point 60 cm (2 ft) to the right of the spectator.
Use a convenient scale and draw the basic diagram in this order.

Draw the Horizon Line a little more than 360 cm (12 ft) above the lower edge of the paper, using a T-square. Mark the centre of vision about the centre of the H.L. Draw the Ground Line 150 cm (5 ft) below the H.L. also with a T-square. From the C.V. draw down the distance to point E., in this case 360 cm (12 ft) using a set-square.

Point A is found by measuring 60 cm (2 ft) along the G.L. to the right of the spectator with a ruler.

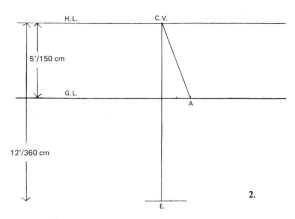

2. A line taken back to the C.V. from A will represent a line 60 cm (2 ft) to the right continuing to the Horizon.

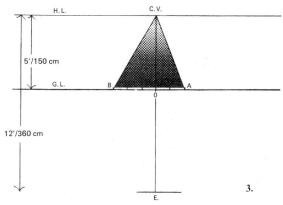

3. To find point B which touches the Ground Line at a point 90 cm (3 ft) to the left of the spectator.

Point B is found in the same manner as point A, only this time measure 90 cm (3 ft) to the left, again using a ruler along the G.L.

From point B a line is taken back to the C.V. and what we now have could represent a straight path 150 cm (5 ft) wide, and disappearing over the Horizon.

Here we have a wide road which is level for part of the way, and then disappears over the brow of a hill.

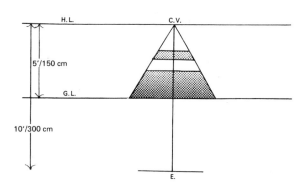

It will now have been observed how much smaller things appear when they are further away. The two squares shown in this diagram are of equal area. This means that we can use a ruler for measuring on the Picture Plane only. Anything else must either be measured by taking it back from the P.P. or alternatively bringing it forward to touch the P.P.

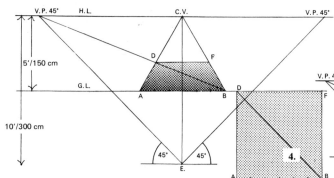

4. If we could draw squares on the G.P. knowing the length of the side touching the P.P. then we would also know the length of the receding sides.

Mark off point A, 90 cm (3 ft) to the left of the spectator and B, 90 cm (3 ft) to the right and take lines from A and from B back to the C.V. Measure angles of 45° at point E. to the left and right and produce the lines to meet the H.L., thus finding the V.P.'s 45° for all lines which recede from the P.P. at this angle.

Take B back to the left V.P. 45° and where it crosses the line from A to the C.V. will be point D, a far corner of the square. A line parallel to AB at D will give point F where it cuts the line from B to the C.V. Thus the square is complete, and the far line DF is 180 cm (6 ft) long, and also the receding lines AD and BF.

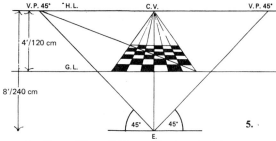

5. Here a 180 cm (6 ft) square has been divided up into smaller squares, equal to one another. This has been done by taking lines back to the C.V. from equal measurements along the G.L. Where these receding lines cut the diagonal line, lines are drawn parallel to the G.L., thus making the 36 smaller squares.

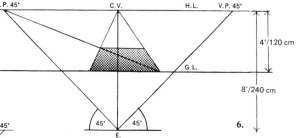

6. There is no need for the square to lie actually in front of the spectator. Here a 150 cm (5 ft) square has the near corner 60 cm (2 ft) to the left of the spectator.

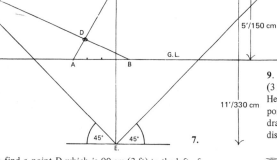

7. To find a point D which is 90 cm (3 ft) to the left of the spectator and 120 cm (4 ft) beyond the P.P.

Measure 90 cm (3 ft) to the left along the G.L. to find point A. Take a line back from A to the C.V. From A measure 120 cm (4 ft) along the G.L. towards the right, and from this point B go back to the V.P. 45° on the left. Where these lines cross is the point required.

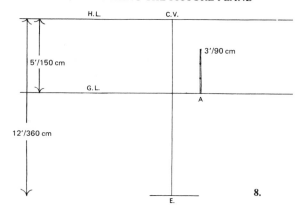

8. Just as actual measurements were taken along the G.L., lines taken up the P.P. can also be measured with a ruler.

At point A which is 60 cm (2 ft) to the right, we have a height line of 90 cm (3 ft). Measure the 90 cm (3 ft) up the P.P. from point A, and this will be the height required.

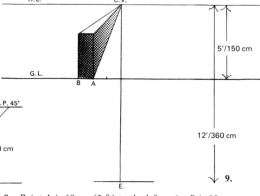

9. Point A is 60 cm (2 ft) to the left, point B is 90 cm (3 ft) to the left, both points touching the P.P. at the G.L. Height lines of 90 cm (3 ft) have been erected at these points and lines taken back to the C.V. Thus we have drawn a wall of 30 cm (1 ft) thick receding into the far distance.

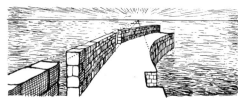

Sketch of wall

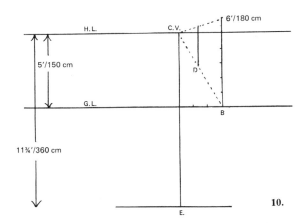

10.

10. Suppose we need a height of 180 cm (6 ft) at point D which is beyond the P.P. We cannot measure this with a ruler but we can measure the height up the Picture Plane. From the C.V. bring D forward along the G.P. to touch the P.P. at B on the Ground Line. Erect the 180 cm (6 ft) at point B with a ruler and from this height take a line back to the C.V. Any vertical line taken up between these two horizontal lines will be 180 cm (6 ft) high, therefore erect the line at D as required.

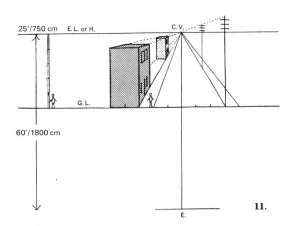

11.

11. If we change the scale we can measure 150 cm (5 ft) wide pavements by using the Ground Line, and even erect a few buildings to make the diagram into a scene. You are now viewing the scene from a height of 750 cm (25 ft), and are looking down on the flat roof of the two-storey house.

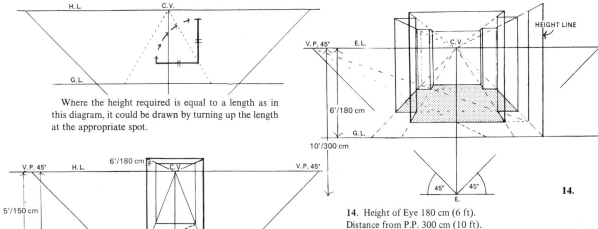

Where the height required is equal to a length as in this diagram, it could be drawn by turning up the length at the appropriate spot.

12.

12. A transparent box, 120 × 120 × 180 cm (4 ft × 4ft × 6 ft) lies immediately in front of the spectator with one side touching the Ground Line. Draw the square base and take a height line up at point B with a ruler. A line taken back from F to the C.V. gives one edge and horizontal lines from this top edge are taken across parallel with the G.L. to give the other side. Vertical lines drawn up from the plan will complete the box.

13. A box construction can soon turn into the interior of a room, and by taking measurements along the Ground Line and up the Picture Plane details may be added.

13.

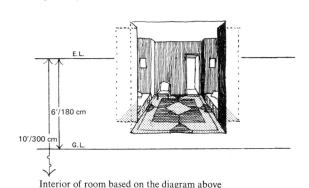

14.

14. Height of Eye 180 cm (6 ft).
Distance from P.P. 300 cm (10 ft).
A 360 cm (12 ft) square lies on the Ground Plane with inverted corners of 60 cm (2 ft) each. The near side of the square is parallel to the P.P. and lies 60 cm (2 ft) beyond.

Interior of room based on the diagram above

For an outdoor sketch make sure that you are more than one and a half times the height away in order to avoid distortion. See page 71.

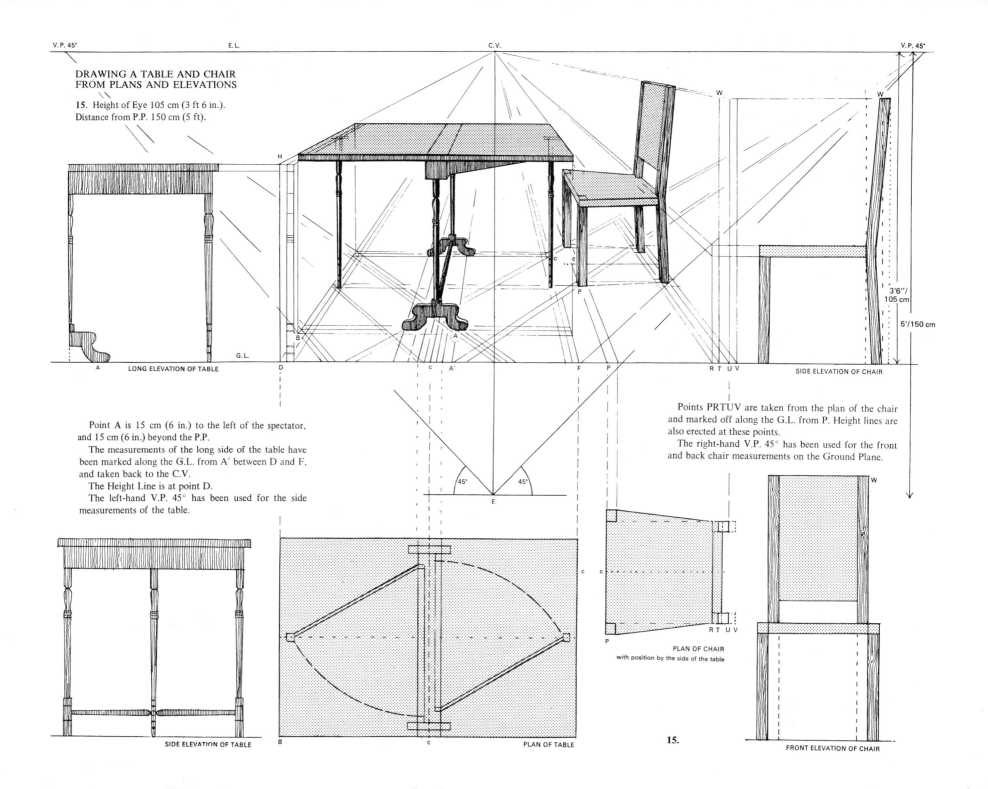

DRAWING A TABLE AND CHAIR
FROM PLANS AND ELEVATIONS

15. Height of Eye 105 cm (3 ft 6 in.).
Distance from P.P. 150 cm (5 ft).

H

G.L.

LONG ELEVATION OF TABLE

B

A

D c A′ F P R T U V SIDE ELEVATION OF CHAIR

3'6"/105 cm

5'/150 cm

Point A is 15 cm (6 in.) to the left of the spectator,
and 15 cm (6 in.) beyond the P.P.

The measurements of the long side of the table have
been marked along the G.L. from A′ between D and F,
and taken back to the C.V.

The Height Line is at point D.

The left-hand V.P. 45° has been used for the side
measurements of the table.

Points PRTUV are taken from the plan of the chair
and marked off along the G.L. from P. Height lines are
also erected at these points.

The right-hand V.P. 45° has been used for the front
and back chair measurements on the Ground Plane.

45° 45°

E.

SIDE ELEVATION OF TABLE

B c PLAN OF TABLE

P R T U V

PLAN OF CHAIR
with position by the side of the table

W

15.

FRONT ELEVATION OF CHAIR

DESIGNING A TOWER ON A SQUARE PLAN

16. Before starting a drawing choose a scale which is to be used throughout. This may depend on the size of the sheet of paper, a centimeter or an inch may represent what you will; and although the square here is given as 180 cm (6 ft), it could easily be 1800 cm (60 ft) instead. One to thirty, or half an inch to one foot may be a convenient scale for the drawing.

Height of Eye 180 cm (6 ft).

Distance from P.P. 300 cm (10 ft).

The 180 cm (6 ft) square plan of the tower lies on the Ground Plane immediately in front of the spectator. The side CD is parallel to the Picture Plane and lies 120 cm (4 ft) beyond.

First draw the basic diagram, i.e. the H.L., G.L., C.V., point E. and the V.P.'s for 45°. Keep the position of point E. well down on the paper because the construction of the height of the tower will come above the Horizon Line.

Mark off 90 cm (3 ft) either side of the spectator on the G.L., thus finding points A and B. From A and B take lines back to the C.V.

From A along the G.L., mark off 120 cm (4 ft) towards the right and take a line back to the left-hand V.P. 45° cutting the line from A to the C.V. at point C.

From C draw a line parallel to the G.L. towards the right, with a T-square, cutting the line from B to the C.V. at D.

From D take a line back towards the left-hand V.P. 45°, cutting the line from A to the C.V. at F.

From F draw a line towards the right, parallel with the G.L., cutting the line from B to the C.V. at G.

CDGF is the plan of the required tower. The inside square is constructed by using the diagonals.

NOTE. In order to avoid a maze of lines some of the pages have been designed on a 'lift-up' principle, the construction lines being on one side of the paper, and eventually leading to the finished drawing on the reverse side. When the page is lifted towards the light, the drawings coincide.

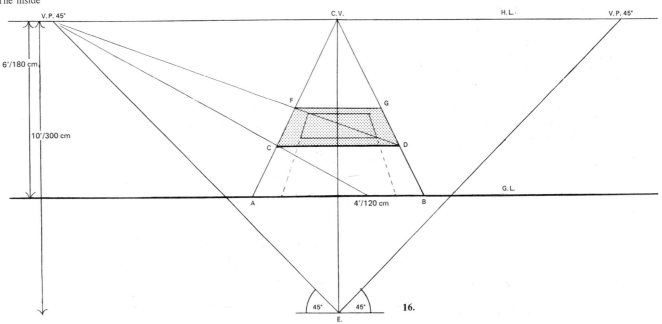

PLAN

16.

A lift-up page

13

The second stage is to erect the height lines.

As this is a 'hold towards the light' page, the plan we have just drawn will be seen showing through the paper, but you, of course, will continue your drawing on the same sheet, i.e. you will raise the height lines on the plan in perspective.

Actual heights must be measured on the Picture Plane with a ruler. Mark the first measurement of 270 cm (9 ft) vertically from A, using a T-square and set-square. This height on the diagram is marked H.

From H take a line back to the C.V. A vertical line up from point C cuts this at point J.

From J draw a line parallel to the G.L. which will cut a vertical line up from D at point K.

Take lines back to the C.V. from J and also from K.

A vertical up from F cuts the line from J to the C.V. at N.

A vertical up from G cuts the line from K to the C.V. at M.

JKMN is the first floor of the tower.

The inner square is drawn by taking lines up from the G.P. and using the diagonal line to the V.P. 45°.

On this inner square, lines of 120 cm (4 ft) have been erected in order to continue the tower upwards. Dotted lines show the construction. The original height line at A is used and a line from the tip of this to the C.V. gives points Q and P.

A diagonal from Q to the V.P. 45° gives point R.

13'/390 cm

9'/270 cm

V.P. 45° H.L. C.V. V.P. 45°

G.L.

45° 45°

E.

From the plan below, it will be seen that an octagon with sides of equal length has been constructed within the square.

In order to do this, angles of 45° were measured at the centre because 360° divided by 8, equals 45°.

From the octagon dotted lines are taken to cut the square between points T and U, on the plan.

To put the octagon into perspective and to avoid a maze of lines, a second 'Ground Line' has been drawn at the Height Line of 390 cm (13 ft).

Naturally, as this line touches the Picture Plane, measurements may be taken along it with a ruler. The receding sides of the square are brought forward to touch this new 'Ground Line' and measurements taken from the plan between T and U are marked off along it.

Lines are taken back to the C.V. from these points.

The dotted diagonal line shows where lines are drawn across parallel to the G.L.

Four sides of the octagon will return to their respective V.P.'s 45°.

Turn the page upside-down if you wish.

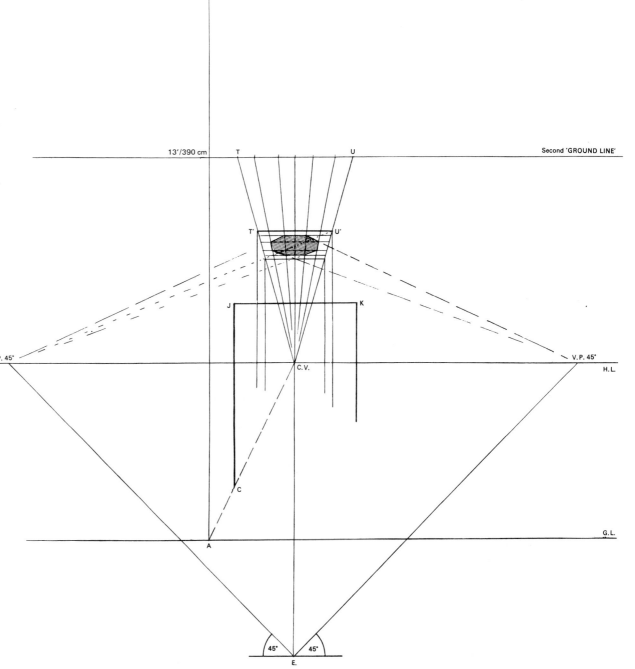

PLAN

A lift-up page

THE COMPLETED TOWER

Gradually the feeling that you are shut in behind the Picture Plane disappears, and you find that you are designing or sketching on a Ground Plane receding into the distance. You are working in the third dimension in a most satisfying way on a flat sheet of paper.

The use of point E. may often be dispensed with, providing you are far enough away for a square in the foreground to be a square and not a receding elongated rectangle. A V.P. 45° may be a necessary check for a first point, in order to find the diagonal through which parallel lines to the Ground Line will be drawn on the Ground Plane.

A lift-up page

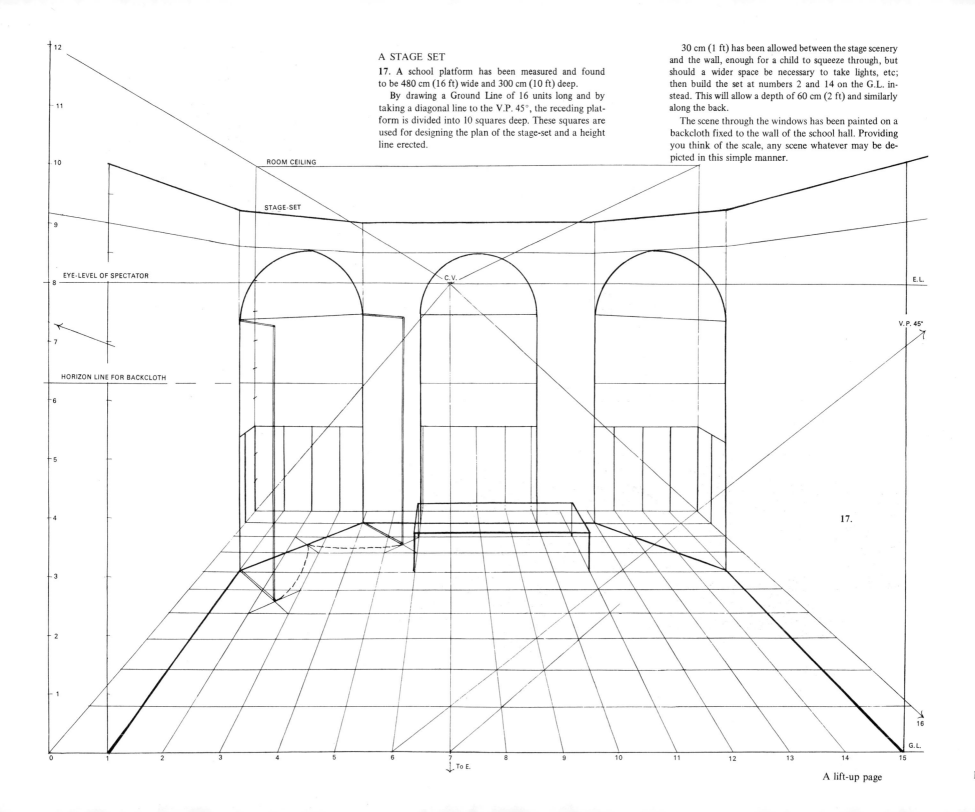

A STAGE SET

17. A school platform has been measured and found to be 480 cm (16 ft) wide and 300 cm (10 ft) deep.

By drawing a Ground Line of 16 units long and by taking a diagonal line to the V.P. 45°, the receding platform is divided into 10 squares deep. These squares are used for designing the plan of the stage-set and a height line erected.

30 cm (1 ft) has been allowed between the stage scenery and the wall, enough for a child to squeeze through, but should a wider space be necessary to take lights, etc; then build the set at numbers 2 and 14 on the G.L. instead. This will allow a depth of 60 cm (2 ft) and similarly along the back.

The scene through the windows has been painted on a backcloth fixed to the wall of the school hall. Providing you think of the scale, any scene whatever may be depicted in this simple manner.

ROOM CEILING

STAGE-SET

EYE-LEVEL OF SPECTATOR

E.L.

C.V.

V.P. 45°

HORIZON LINE FOR BACKCLOTH

17.

16

G.L.

To E.

A lift-up page

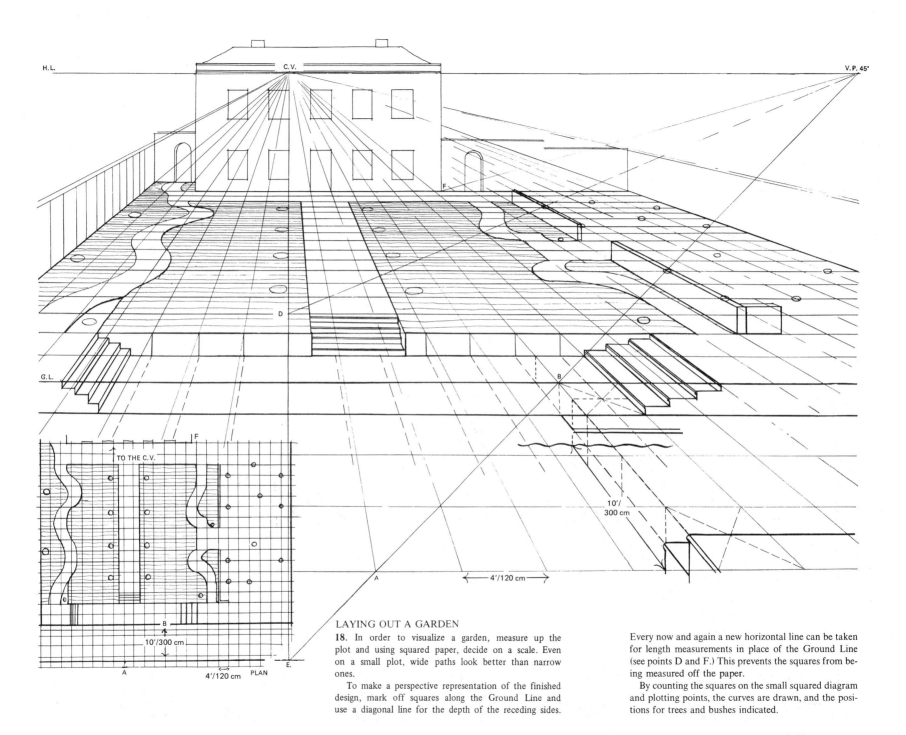

H.L.　　　C.V.　　　V.P. 45°

G.L.

TO THE C.V.

10'/300 cm

4'/120 cm

10'/300 cm

4'/120 cm　PLAN

LAYING OUT A GARDEN

18. In order to visualize a garden, measure up the plot and using squared paper, decide on a scale. Even on a small plot, wide paths look better than narrow ones.

To make a perspective representation of the finished design, mark off squares along the Ground Line and use a diagonal line for the depth of the receding sides.

Every now and again a new horizontal line can be taken for length measurements in place of the Ground Line (see points D and F.) This prevents the squares from being measured off the paper.

By counting the squares on the small squared diagram and plotting points, the curves are drawn, and the positions for trees and bushes indicated.

A lift-up page

19

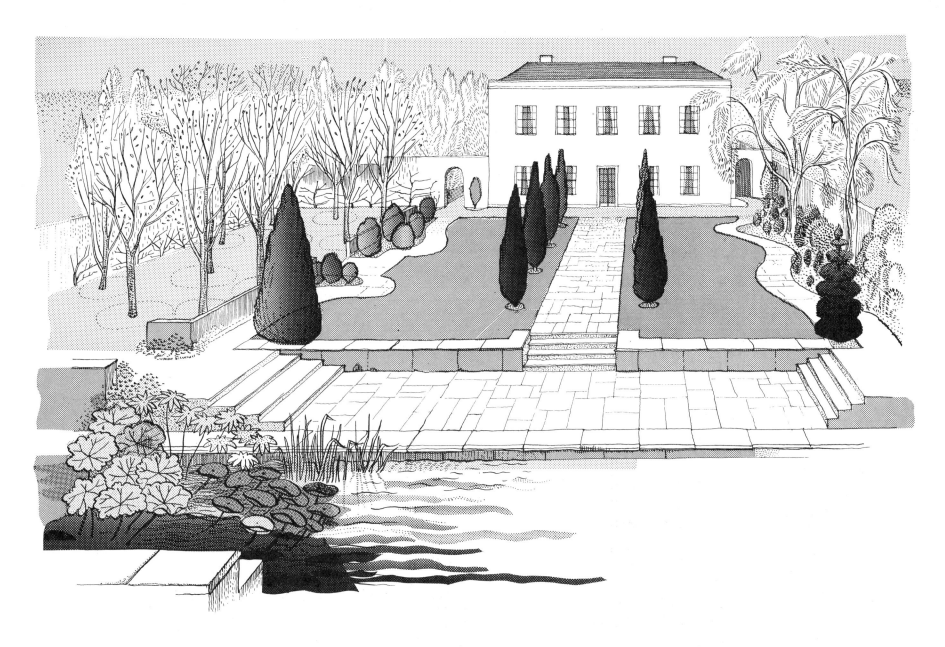

Heights are erected by turning up the width of a
square at the appropriate point. In this diagram the
length of any square turned up at right angles will give
a height of 120 cm (4 ft). By holding this page towards
the light, the plan will be shown shining through the paper.
The tones give a feeling of depth as so far we have not
learnt how to cast shadows.

A lift-up page

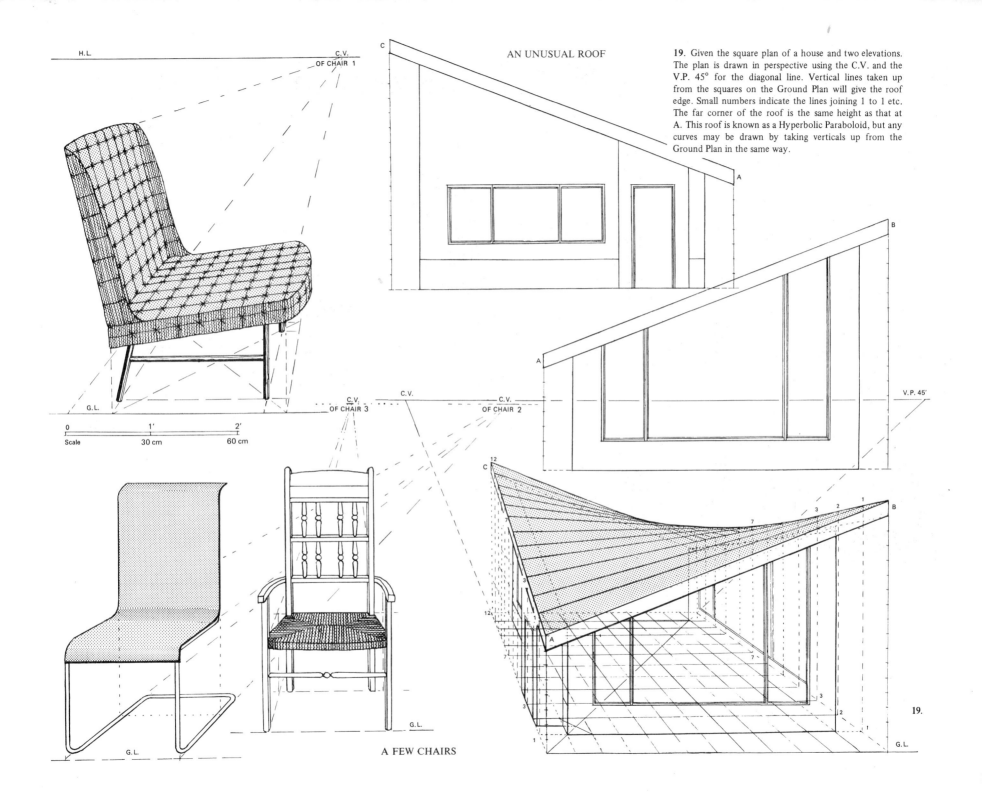

AN UNUSUAL ROOF

19. Given the square plan of a house and two elevations. The plan is drawn in perspective using the C.V. and the V.P. 45° for the diagonal line. Vertical lines taken up from the squares on the Ground Plan will give the roof edge. Small numbers indicate the lines joining 1 to 1 etc. The far corner of the roof is the same height as that at A. This roof is known as a Hyperbolic Paraboloid, but any curves may be drawn by taking verticals up from the Ground Plan in the same way.

A FEW CHAIRS

19.

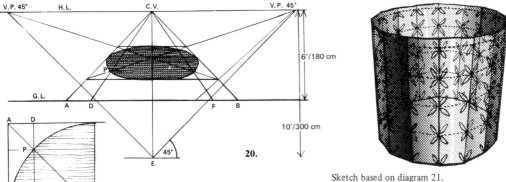

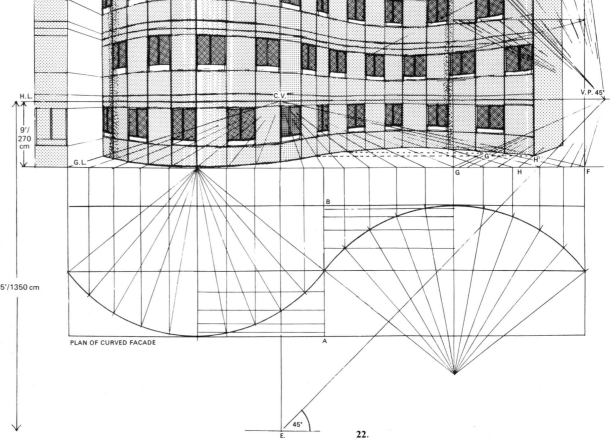

22. The plan is given for the curved façade of a block of flats. The point E. is 1½ times the height of the block away. Lines from the plan have been taken up to touch the G.L. and then taken back to the C.V.

Points where the curves intersect have been marked on the line AB. To avoid a confusion of lines, the measurements along AB have been marked at FG on the Ground Line and taken back to the right-hand V.P. 45° Where these cross the lines from F to the C.V. at H′ and G′, lines are drawn parallel to the G.L. These are shown by dots.

The line at the top of the drawing marked MN also touches the P.P. and can be used as a further check. Points G², H², and F² have been taken down to the V.P. 45°, and parallel lines taken across in the same manner.

Sketch based on diagram 21.

CURVES

20. Height of Eye 180 cm (6 ft).

Distance from P.P. 300 cm (10 ft).

A 360 cm (12 ft) square lies on the G.P. parallel with the P.P. and 90 cm (3 ft) beyond. A circle is constructed within the square,

In order to draw a circle a plan must first be drawn. A quarter of a circle is sufficient in order to draw a diagonal line to cut the circumference of the circle. At P draw lines to cut the square parallel to the sides of the square, thus giving a short length AD.

This length AD is then marked on the G.L. from point A on the G.L. towards the right, and a line from D taken back to the C.V. cutting the diagonals of the square at two new points. Similarly the length FB can be marked along the G.L. equal to AD, and a line taken back to the C.V. from F, thus giving two more points for the circumference of the circle which can now be sketched in.

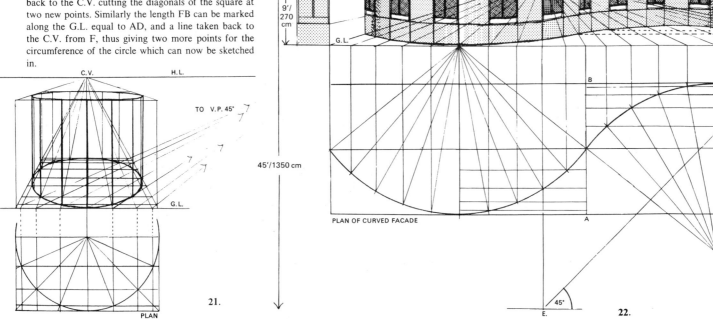

A SPIRAL STAIRCASE

23. Height of Eye 165 cm (5½ ft).
Distance from P.P. 300 cm (10 ft).

The stairs ascend around a column at equal angles from the centre of the column. The plan on the Ground Plane shows one complete revolution consisting of 16 steps.

Draw a quarter plan and enclose the circle within a square. Mark enough construction lines in order to plot the points on the Ground Plane.

A line from the V.P. 45° through the centre of the column to touch the G.L. gives point J, at which the Height Line for the 16 steps has been erected.

Point A on the circumference is brought forward from the C.V. to touch the G.L., the height of the first step erected, and taken back to the C.V. Similarly with B, only this time the height of two steps is erected, and so on. Return to the centre of the column for the treads.

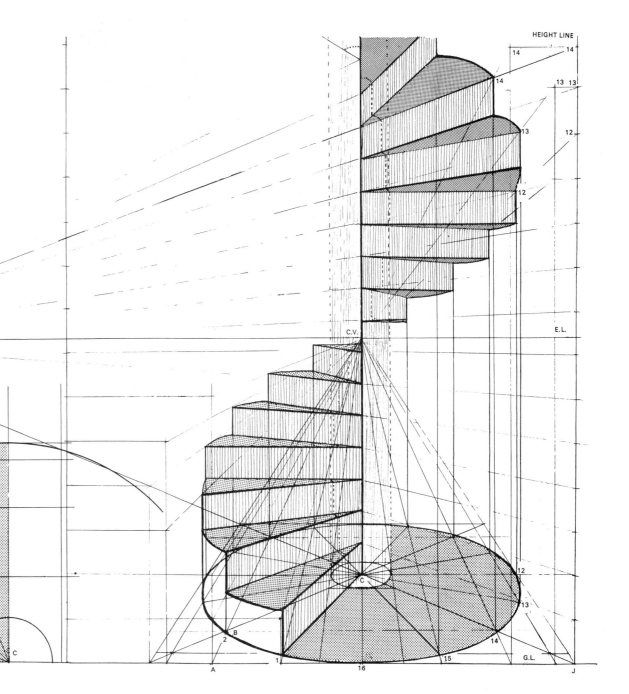

23.

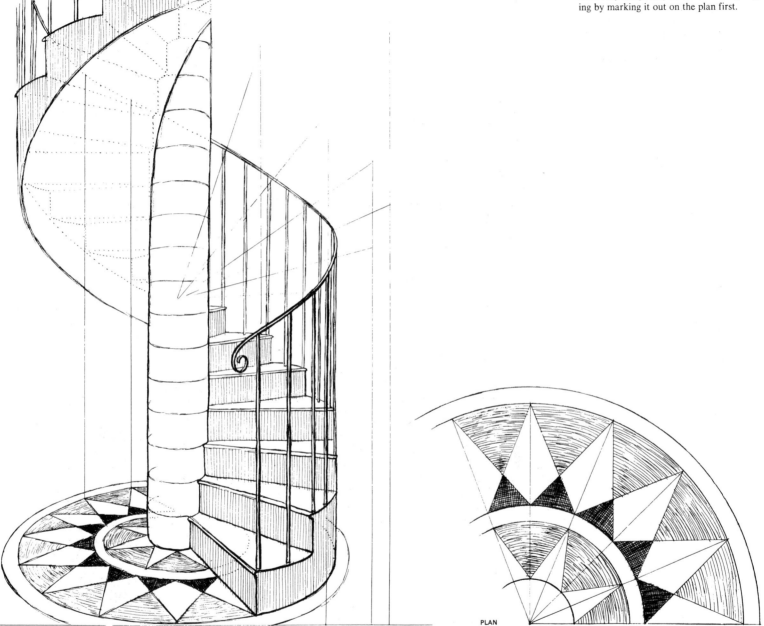

COMPLETING THE SKETCH

Banisters, etc. are drawn in by using the same height lines. Any design may be added to the perspective drawing by marking it out on the plan first.

PLAN

REFLECTIONS IN WATER

The surface of undisturbed water is as the surface of a mirror, lying in a horizontal plane.

Vertical lines of objects are continued below the surface, and measurements equal to that of the object are taken, and measured off. Even if the object is a complicated shape, verticals may still be dropped and equal measurements taken, horizontal lines returning to their respective Vanishing Points.

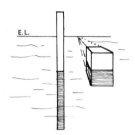

Vertical objects

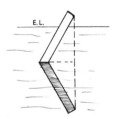

A plank slanting to one side and parallel to the Picture Plane

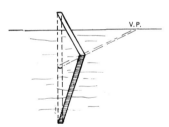

A post slanting towards the spectator

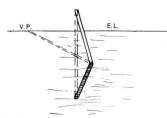

A post slanting away from spectator

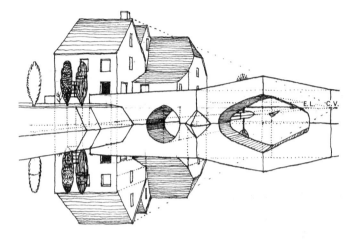

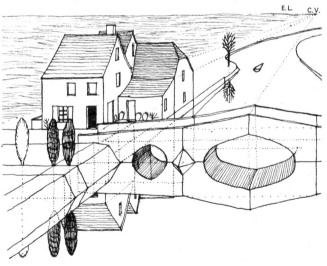

The two drawings above show the same scene viewed from the same position, but from a different Eye-level. This may be necessary as a background to a story or a film-strip. Given plans and elevations, numerous views may be chosen and put into perspective without the need of building a model.

Dotted lines show where verticals have been dropped for more complicated objects.

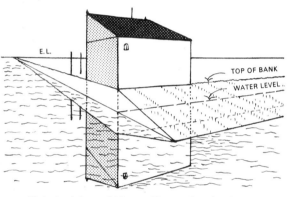

If the bank has a thickness, this must be taken into consideration before dropping verticals to the water level.

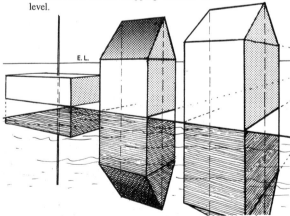

Although we can cast reflections for the two diagrams above, note that the lines not parallel to the Picture Plane do not vanish to the C.V. This leads us on to the next section.

ANGULAR PERSPECTIVE

Until now, all our objects to be put into perspective have had some part parallel or at right-angles to the Ground Line. Therefore it has always been possible to take their actual measurements along the Ground Line or up the Picture Plane.

Even if a square should lie on the Ground Plane in such a position that the *sides* vanish towards the V.P.'s 45°, one of the diagonals of the square will be parallel to the Ground Line and we can measure this instead.

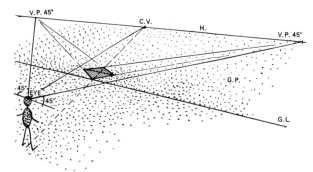

This diagram shows the spectator looking at such a square on the Ground Plane.

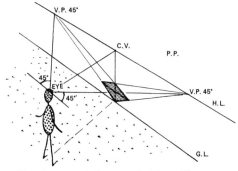

Here the square is drawn on the Picture Plane as seen from the side.

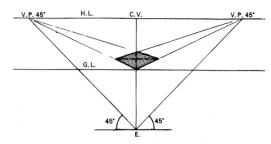

Here the square is drawn on the Picture Plane as seen from the front.

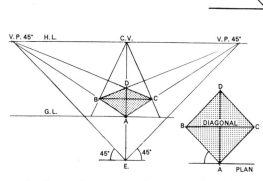

The diagram shows a square lying on the G.P. with sides vanishing towards the V.P.'s 45°. It will be seen from the plan that one of the diagonals of the square is parallel to the G.L. and the other diagonal vanishes to the C.V.

By marking the length of the diagonal along the G.L. with a ruler, and marking off its distance beyond the G.L., the square can be drawn in the usual manner.

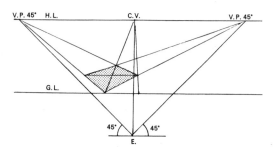

Should the square lie slightly to the left or to the right of the spectator, i.e. the C.V.R., the diagonal will still be parallel to the Ground Line.

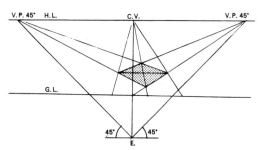

And when the square lies beyond the Picture Plane, the same method can be used.

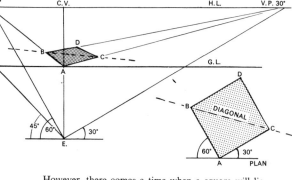

However, there comes a time when a square will lie in such a position that neither the sides nor diagonals are parallel to the Ground Line, and when this is the case, some other method of drawing the square in perspective will have to be devised. Naturally a diagonal lying in the position of that in the above diagram cannot be measured with a ruler along the Ground Line.

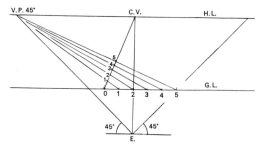

You will remember that to measure distances along lines which vanished towards the C.V., the distances were measured along the G.L. and then taken back to a V.P. 45°, cutting the line at the required places.

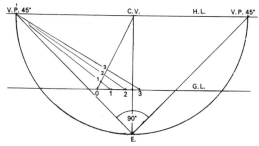

Instead of measuring the angles 45° at point E. we could have obtained the V.P.'s 45° by taking the distance from the C.V. to point E. and describing a semi-circle with the C.V. as a centre, thus cutting the H.L. in two places. These points are the V.P.'s 45°. (By geometry, the angle in a semi-circle is a right-angle.)

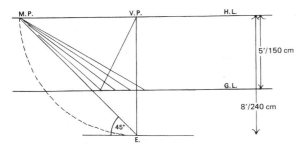

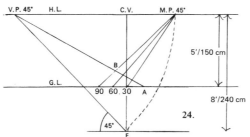

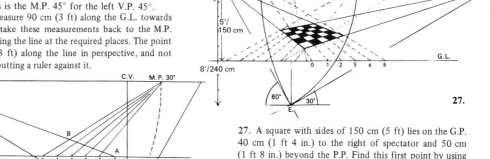

As the V.P.'s 45° are used for measuring the distances along lines vanishing towards the C.V., it could be said that the V.P.'s 45° are the Measuring Points for lines when the C.V. is their Vanishing Point.

Therefore to measure distances along a line vanishing to a V.P. we have found the Measuring Point by taking the distance from the V.P. to point E., and with the V.P. as a centre, we have described an arc to cut the H.L. This is the MEASURING POINT.

The C.V. is the only Vanishing Point which has a Measuring Point on either side of it. If the line is on the left of the C.V.R. it is usual to use the left-hand M.P. and if on the right then the right-hand M.P. is used.

To find a Measuring Point for a Vanishing Point, take the distance of the V.P. to point E., and with the V.P. as a centre describe an arc to cut the line containing the Vanishing Point, and where it cuts will be the Measuring Point required.

Examples.

24. With height of Eye 150 cm (5 ft) and distance from P.P. 240 cm (8 ft), a line vanishes towards the left V.P. 45°. This line touches the G.L. at a point 30 cm (1 ft) to the right of the spectator. To measure 90 cm (3 ft) along this line, first find the M.P.

Take the distance from the left V.P. 45° to E. and with this V.P. as a centre, describe an arc to cut the H.L. Where it cuts is the M.P. 45° for the left V.P. 45°.

From A measure 90 cm (3 ft) along the G.L. towards the left, and take these measurements back to the M.P. 45°, thus cutting the line at the required places. The point B is 90 cm (3 ft) along the line in perspective, and not measured by putting a ruler against it.

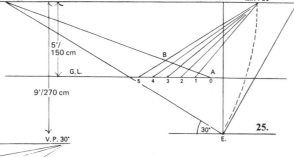

25. Height of Eye 150 cm (5 ft).
Distance from P.P. 270 cm (9 ft).

A line AB vanishes towards the left at an angle of 30° with the P.P. Point A touches the G.L. at 30 cm (1 ft) to the left of the spectator. The line AB is to be divided into five equal parts of 30 cm (1 ft) each.

At E. measure 30° with a protractor to find the V.P. 30° on the H.L. With this V.P. as a centre and with radius from this point to E., describe an arc cutting the H.L. at a point which will be the M.P. 30°.

From A measure the 150 cm (5 ft) along the G.L. towards the left, and take these five points back to the M.P. 30°. The line AB is now cut into five equal parts.

26. Here the row of houses of equal widths goes towards the left V.P. 45°. Measurements have been taken along the G.L. and the dotted lines show these returning to the M.P. 45°.

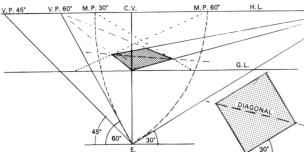

PLAN

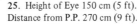

We can now return to the diagram where the diagonal was not parallel to the Ground Line. The square has been put into perspective by using the M.P.'s for the V.P.'s.

Squares or rectangles on the Ground Plane can now be drawn in whatever direction we wish. Be sure that you always return to the V.P. you came from, and remember that to find an M.P. the point E. must always be used.

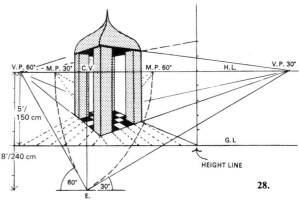

27. A square with sides of 150 cm (5 ft) lies on the G.P. 40 cm (1 ft 4 in.) to the right of spectator and 50 cm (1 ft 8 in.) beyond the P.P. Find this first point by using the C.V., and the V.P. 45°. The sides of the square vanish to the left V.P. 60° and the right V.P. 30°. Each M.P. is used for dividing the square into 25 squares.

28. Height lines can be taken at any convenient place along the Ground Line and a vertical erected. Here the V.P. 60° has been brought forward from the back of the building to meet the G.L., a Height Line erected and the top taken back to the same V.P. 60°.

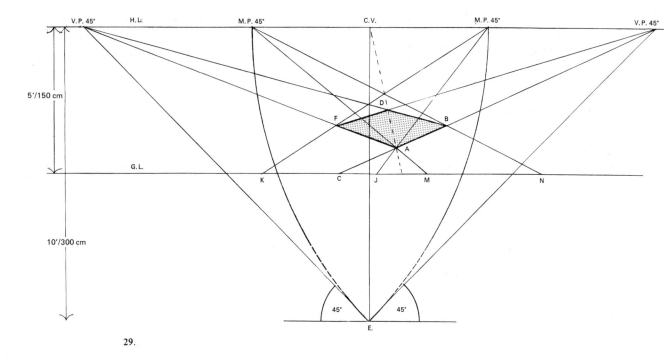

29. Height of Eye 150 cm (5 ft).
Distance from P.P. 300 cm (10 ft).

ABDF is a 120 cm (4 ft) square lying on the G.P. with near corner A 35 cm (1 ft 2 in.) to the right of spectator, and 65 cm (2 ft 2 in.) beyond the P.P. The side AB vanishes to the right at 45°.

Find A in the usual manner, and from A take lines to the V.P.'s 45°.

With the V.P.'s as centres and the distances to point E. as radii, describe arcs to cut the H.L., thus giving the M.P.'s required.

(Note the right-hand V.P. has its M.P. on the left of the C.V., and the left-hand V.P. has its M.P. on the right.)

To measure along AF, come forward through A from the right-hand M.P. to meet the G.L. at J.

From J measure the 120 cm (4 ft) required, along the G.L. to point K.

From K return to the same M.P. 45° cutting the line from A to the left-hand V.P. 45° at point F. Thus AF equals JK. From F vanish to the right V.P. 45°.

Do the same again for the other side, i.e. bring A to the front from the M.P. 45° for the right-hand V.P., touching the G.L. at M.

From M measure 120 cm (4 ft) along the G.L. to N. From N return to the same M.P. cutting the line from A to the V.P. at B.

From B vanish to the left-hand V.P., cutting the line from F to the other V.P. at D.

Thus the square ABDF is complete.

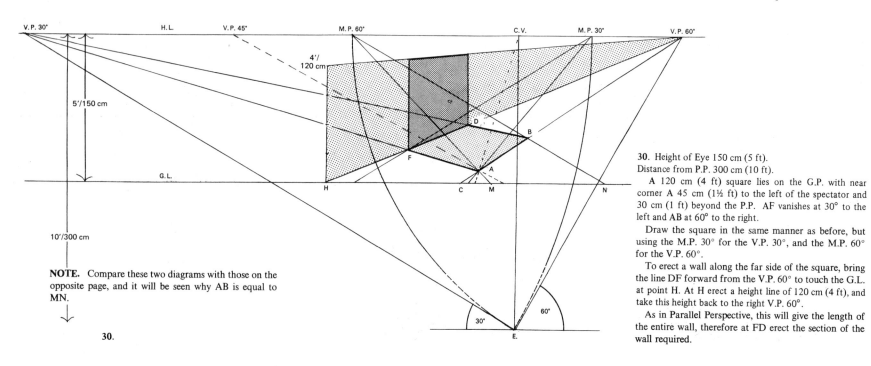

NOTE. Compare these two diagrams with those on the opposite page, and it will be seen why AB is equal to MN.

30. Height of Eye 150 cm (5 ft).
Distance from P.P. 300 cm (10 ft).

A 120 cm (4 ft) square lies on the G.P. with near corner A 45 cm (1½ ft) to the left of the spectator and 30 cm (1 ft) beyond the P.P. AF vanishes at 30° to the left and AB at 60° to the right.

Draw the square in the same manner as before, but using the M.P. 30° for the V.P. 30°, and the M.P. 60° for the V.P. 60°.

To erect a wall along the far side of the square, bring the line DF forward from the V.P. 60° to touch the G.L. at point H. At H erect a height line of 120 cm (4 ft), and take this height back to the right V.P. 60°.

As in Parallel Perspective, this will give the length of the entire wall, therefore at FD erect the section of the wall required.

A GEOMETRIC PROOF FOR A MEASURING POINT

31. Height of Eye 150 cm (5 ft).
Distance from P.P. 300 cm (10 ft).

The plan is given of an isosceles triangle CNB lying on the Ground Plane. The angle NCB is 45°, the line MA is parallel to the base NB. The apex C touches the G.L. at a point 30 cm (1 ft) to the left of the spectator, CN touches the G.L., and CB vanishes towards the right at 45°.

The base angles of an isosceles triangle are equal, therefore 180° – 45° equals 135°, so these angles will be 67½° each.

As MA is parallel to NB, it follows that AB is equal to MN, by geometry, therefore by using the V.P. 67½° we have cut off required distances along a line vanishing to the V.P. 45°.

Find point C, measure CMN along the G.L. towards the right, take lines from M and N back to the V.P. 67½°, cutting the line from C to the V.P. 45° at A and B.

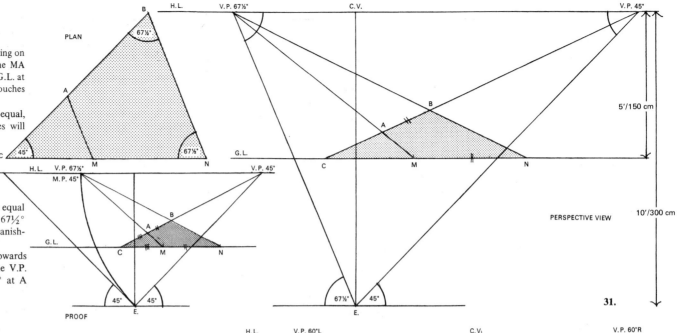

32. Height of Eye 150 cm (5 ft).
Distance from P.P. 300 cm (10 ft).

An equilateral triangle CNB lies on the G.P. with apex C touching the G.L. at 60 cm (2 ft) to the left of spectator. CN touches the G.L., therefore as all the angles of the triangle are 60° each, CB vanishes to the right-hand V.P. 60°, and the base NB to the left-hand V.P. 60°.

MA is parallel to NB, therefore AB is equal to MN, and again we have cut off required distances along a line vanishing to the V.P. 60° by using the other V.P. 60°.

Notice in example **31**, the distance between the V.P. 45° and E. is equal to the distance between V.P. 45° and the V.P. 67½°.

In example **32**, the distance between V.P. 60° R to E. equals the distance between V.P. 60° R and V.P. 60° L.

In these examples, the V.P. 67½° and the V.P. 60° L were both used as Measuring Points. Therefore to find the M.P. for a V.P., take the distance from the V.P. to E. and with the V.P. as centre, describe an arc cutting the H.L. This point will be the M.P. required.

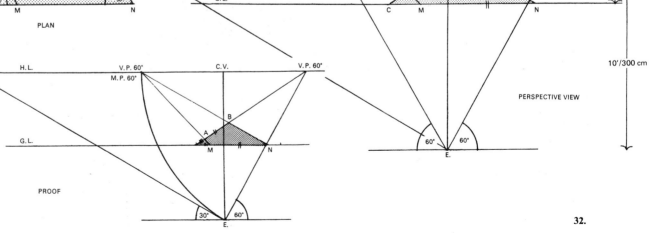

A WRITING DESK FROM PLAN AND ELEVATIONS

33. Height of Eye 90 cm (3 ft).
Distance from P.P. 132 cm (4 ft 4½ in.).

The front of the desk vanishes towards the right at 30°, and the sides at 60° to the left.

Point A is 40 cm (1 ft 4 in.) to the right of spectator, and 20 cm (8 in.) beyond the P.P.

First find point A, by using the V.P. 45°. Take lines back to the V.P. 60° and the V.P. 30°, and find the M.P.'s for these V.P.'s. Bring A forward to the G.L. from each M.P.

Take lines up from the plan to the G.L., and return the front measurements to the M.P. 30°, and the side measurements to the M.P. 60°, cutting the lines from A to the V.P.'s and the lines from B to the V.P.'s.

A line from the V.P. 30° forward through A to touch the G.L. gives point H for the Height Line for the top of the desk.

A line forward from the V.P. 30° through B will give Height Line at J for drawers, etc.

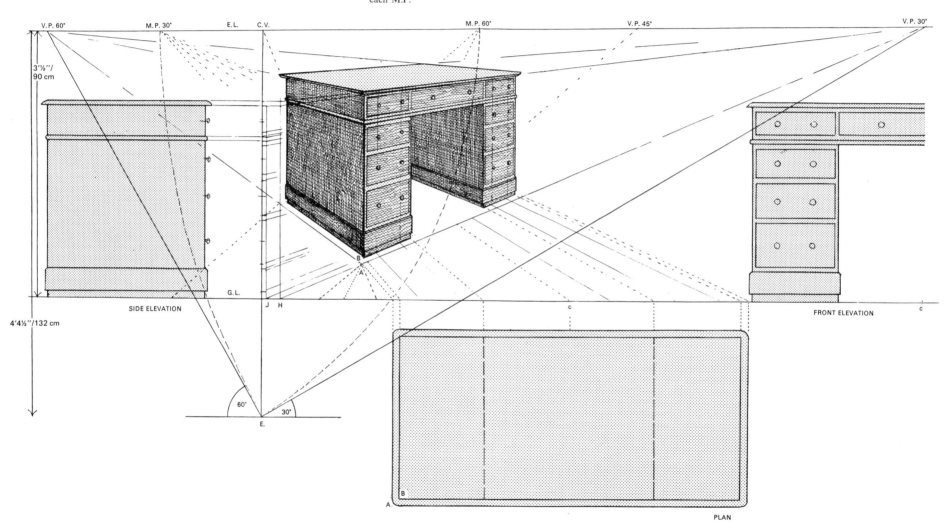

33.

AN ARCHED BUILDING CONSTRUCTED IN FOUR STAGES

34. Height of Eye 210 cm (7 ft).
Distance from P.P. 420 cm (14 ft).

The plan of nine 90 cm (3 ft) square piers is shown on the Ground Plane in perspective. Each pier is 240 cm (8 ft) apart and their sides vanish to the V.P.'s 45°. Point A touches the G.L. at a point 90 cm (3 ft) to the left of the spectator. By drawing the diagonals of the piers parallel to the Picture Plane, extra lines have been avoided.

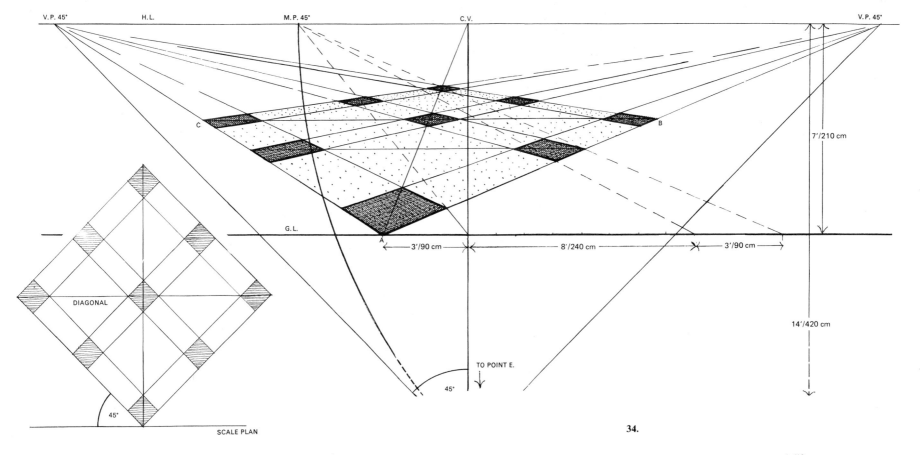

V.P. 45° H.L. M.P. 45° C.V. V.P. 45°

7'/210 cm

C B

G.L.

A ← 3'/90 cm → ← 8'/240 cm → ← 3'/90 cm →

14'/420 cm

DIAGONAL

TO POINT E.

45°

45°

SCALE PLAN

34.

The Height Line is erected at point A. AJ is 330 cm (11 ft), AH is 450 cm (15 ft). A diagram showing the elevation of an arch is drawn in order that the diagonal lines of the square containing the arch can be found. These are necessary for plotting the points K and L which are found by using the point M on the plan marked down from H on the Height Line. NM on plan equals HM on Height Line. MQ on plan equals MJ on Height Line.

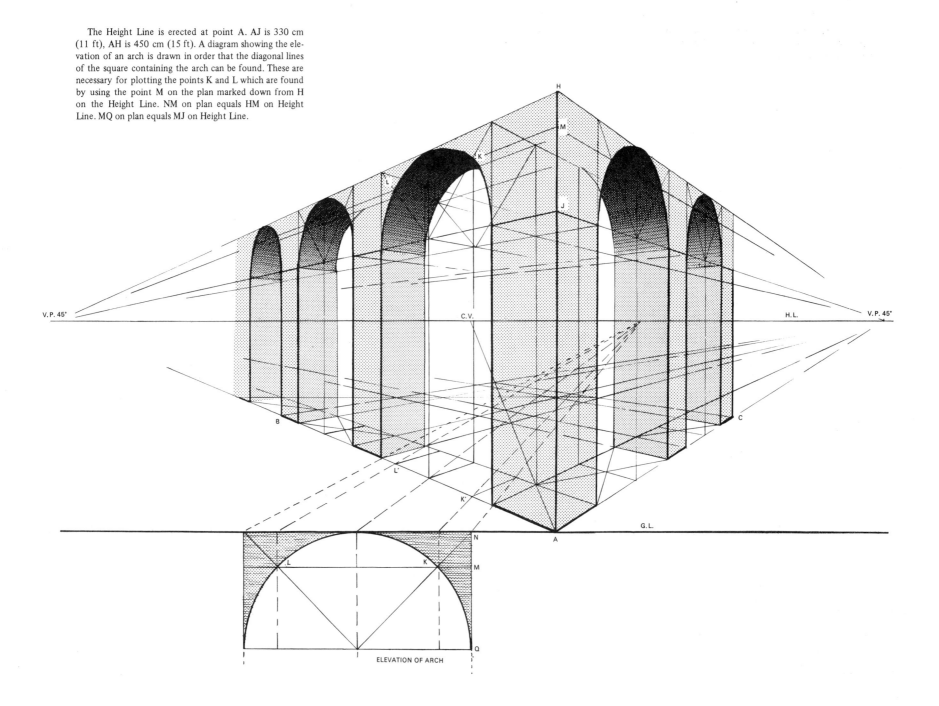

ELEVATION OF ARCH

Details have been added by dividing each pier into
four smaller piers and smaller arches drawn. This is to
show what can be done with a simple plan.

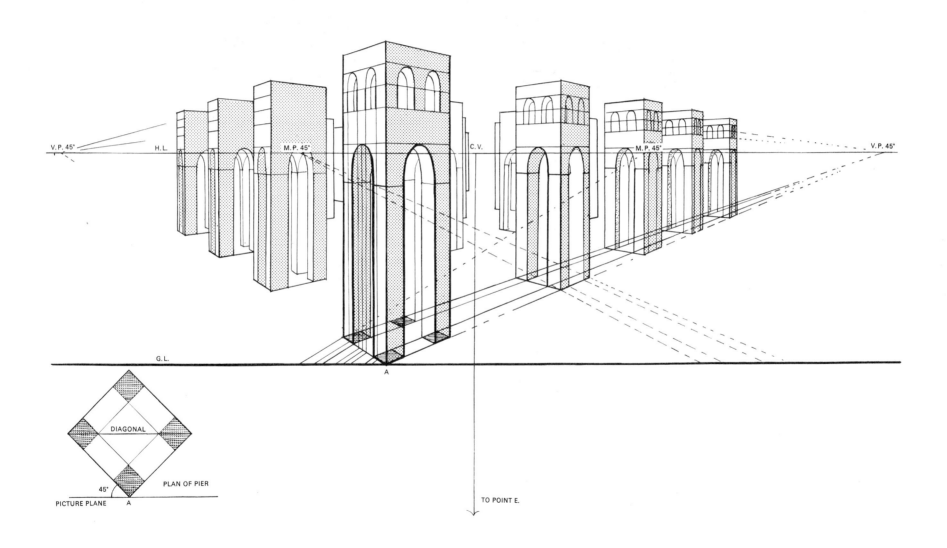

V.P. 45° H.L. M.P. 45° C.V. M.P. 45° V.P. 45°

G.L.

A

DIAGONAL

PLAN OF PIER

45°

PICTURE PLANE A

TO POINT E.

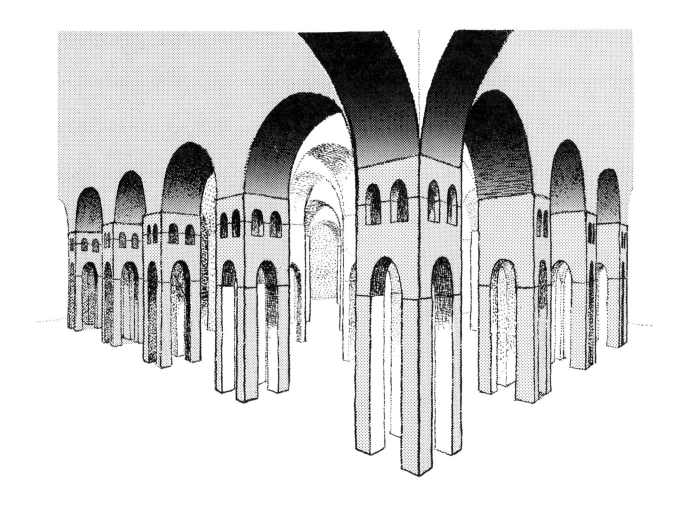

THE FINISHED ARCHES

Here the drawing has been sketched in, and the construction lines omitted. These four pages of the arched building are on the 'hold towards the light' principle, but naturally your drawing would be on one sheet of paper only.

A lift-up page

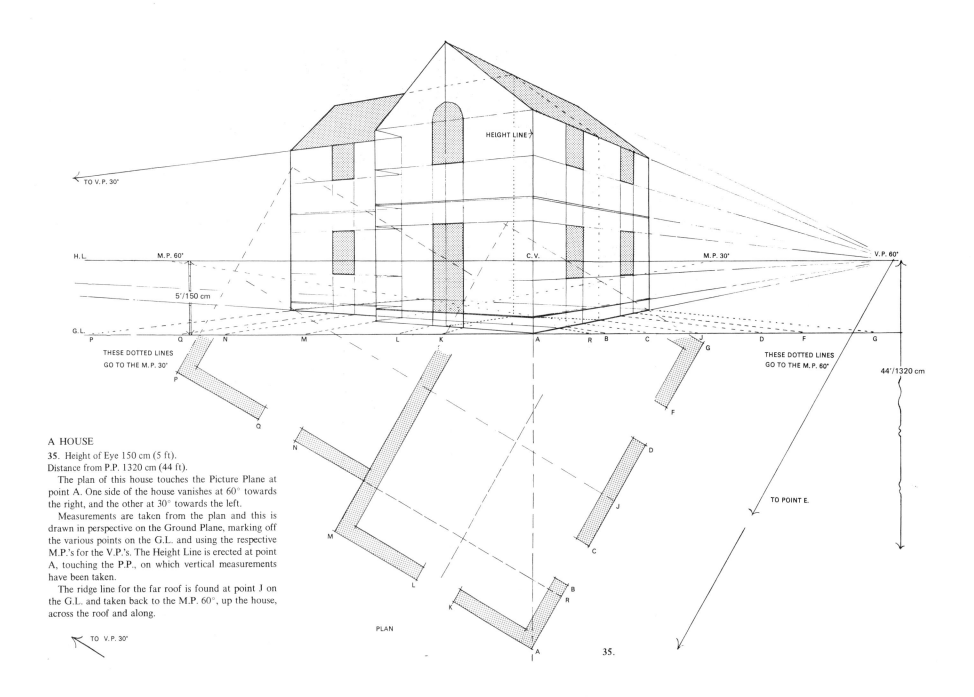

TO V.P. 30°

HEIGHT LINE

H.L. M.P. 60° C.V. M.P. 30° V.P. 60°

5'/150 cm

G.L. P Q N M L K A R B C J D F G

THESE DOTTED LINES
GO TO THE M.P. 30°

THESE DOTTED LINES
GO TO THE M.P. 60°

44'/1320 cm

TO POINT E.

A HOUSE

35. Height of Eye 150 cm (5 ft).
Distance from P.P. 1320 cm (44 ft).

The plan of this house touches the Picture Plane at point A. One side of the house vanishes at 60° towards the right, and the other at 30° towards the left.

Measurements are taken from the plan and this is drawn in perspective on the Ground Plane, marking off the various points on the G.L. and using the respective M.P.'s for the V.P.'s. The Height Line is erected at point A, touching the P.P., on which vertical measurements have been taken.

The ridge line for the far roof is found at point J on the G.L. and taken back to the M.P. 60°, up the house, across the roof and along.

TO V.P. 30°

PLAN

35.

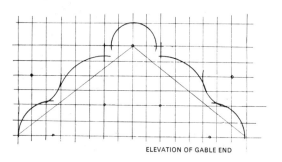

ELEVATION OF GABLE END

PLAN OF STEPS

When the drawing of the bare outline of the house is finished, details can be added as desired. Supposing the house was one to be altered or redesigned, a complete effect can be visualized by sketching on the outline drawing. This is so much more useful for a client than a mere elevation.

A lift-up page

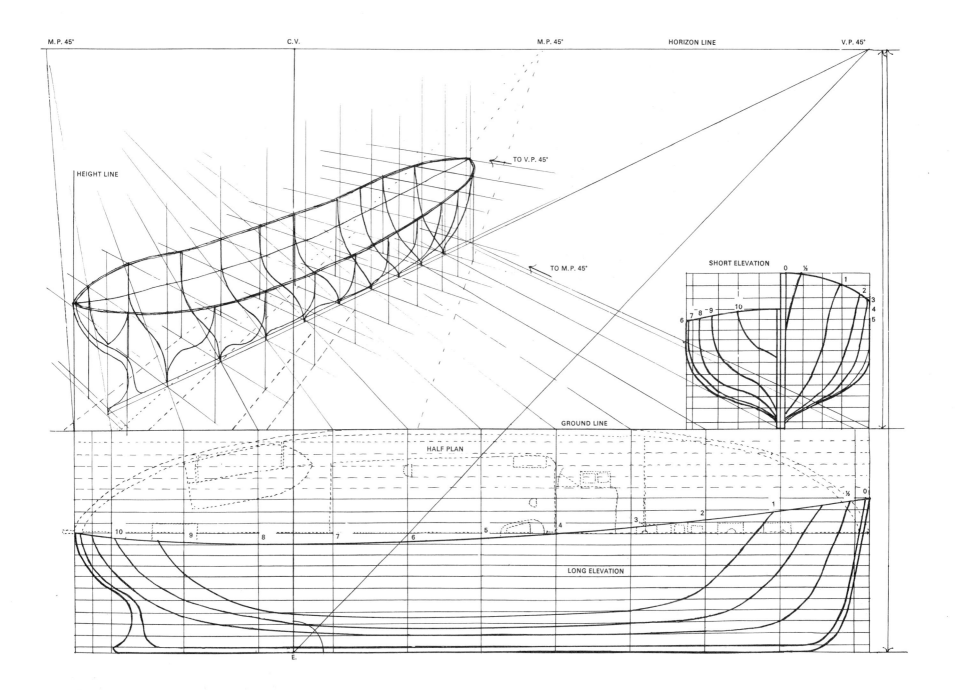

M.P. 45° C.V. M.P. 45° HORIZON LINE V.P. 45°

HEIGHT LINE

TO V.P. 45°

TO M.P. 45°

SHORT ELEVATION

GROUND LINE

HALF PLAN

10 9 8 7 6 5 4 3 2 1 ½ 0

LONG ELEVATION

E.

A BOAT

36. This is put into perspective by using the plans and
elevations.

36.

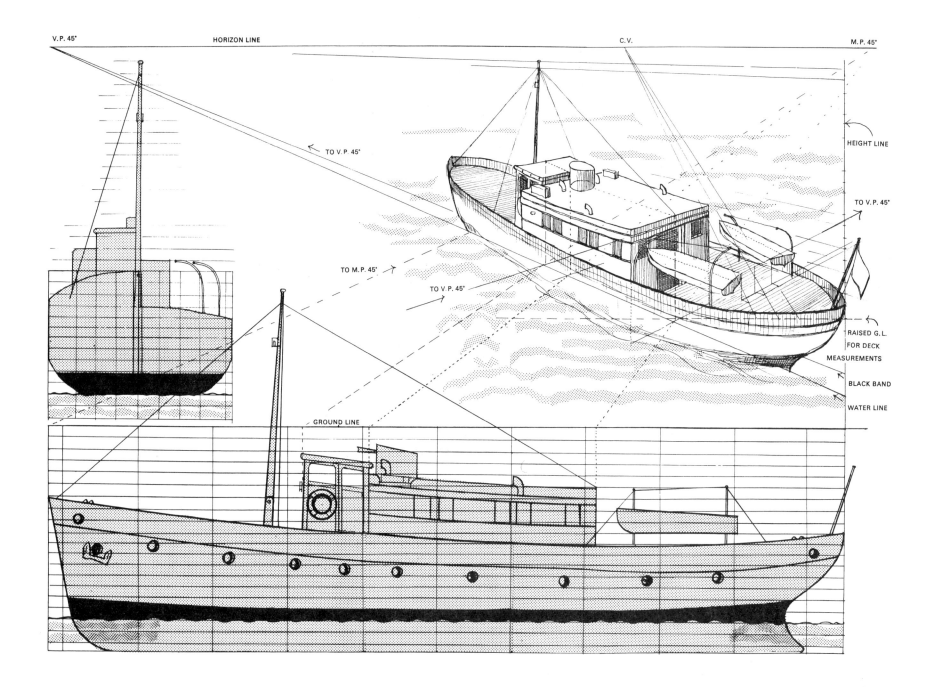

V.P. 45° HORIZON LINE C.V. M.P. 45°

HEIGHT LINE

TO V.P. 45°

TO V.P. 45°

TO M.P. 45°

TO V.P. 45°

RAISED G.L.
FOR DECK
MEASUREMENTS

BLACK BAND

WATER LINE

GROUND LINE

A lift-up page

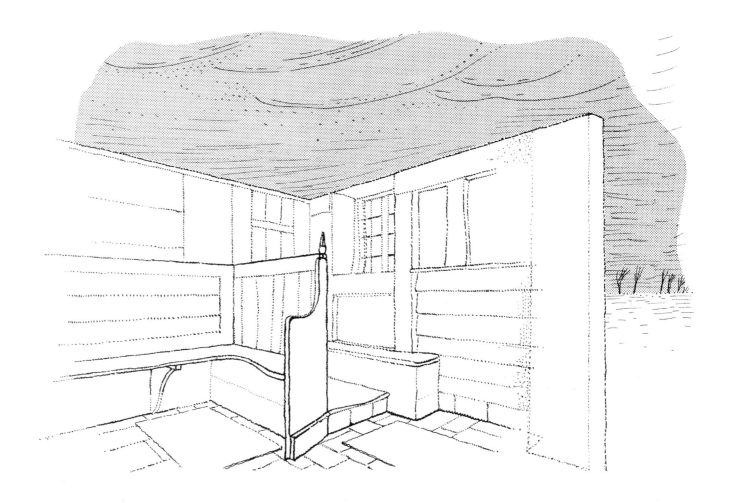

A FILM-SET

37. As many of these are filmed in the open air, ceilings must be added to those sets in which interiors are depicted. This is necessary where the scene is a very small room, with insufficient space for cameras or in scenes where a built ceiling would dim the lighting effects.

Assume this drawing to be a photograph of a built set. The Eye-level must be ascertained, and the two Vanishing Points found.

37.

A lift-up page

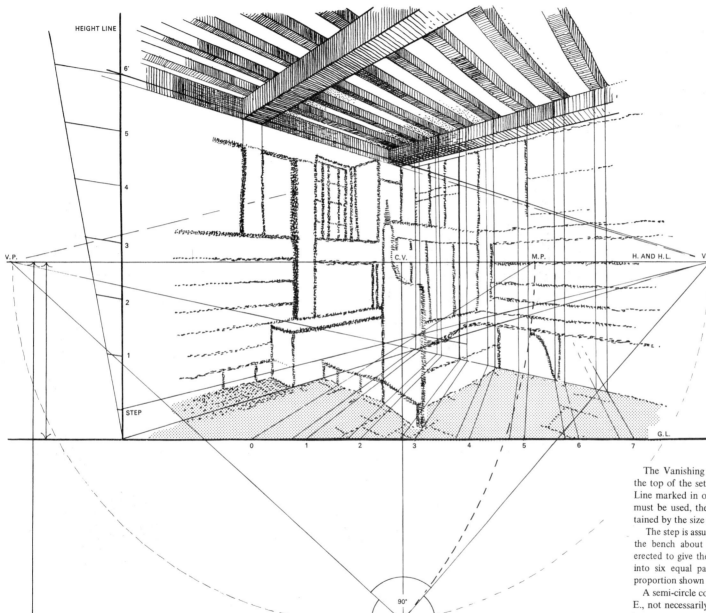

HEIGHT LINE

6'

5

4

3

2

1

STEP

V.P.

C.V. M.P. H. AND H.L. V.P.

G.L.

0 1 2 3 4 5 6 7

90°

E.

The Vanishing Points are found by following along the top of the set down to the Horizon, and a Ground Line marked in order to give the scale. Common sense must be used, the relative size of a figure being ascertained by the size of a door or a chair.

The step is assumed to be about 18 cm (7 in.) high, and the bench about 30 cm (1 ft) above. A Height Line is erected to give the scale of the doorway. This was divided into six equal parts by using the geometric method of proportion shown at the side of the diagram.

A semi-circle containing the two V.P.'s will give point E., not necessarily halfway along the H.L. between the two.

M.P.'s can be found by using point E.

The roof is drawn by using the V.P.'s. If an old effect is required, first draw it as new and later sag the beams where you wish. When the drawing is complete it will be photographed again.

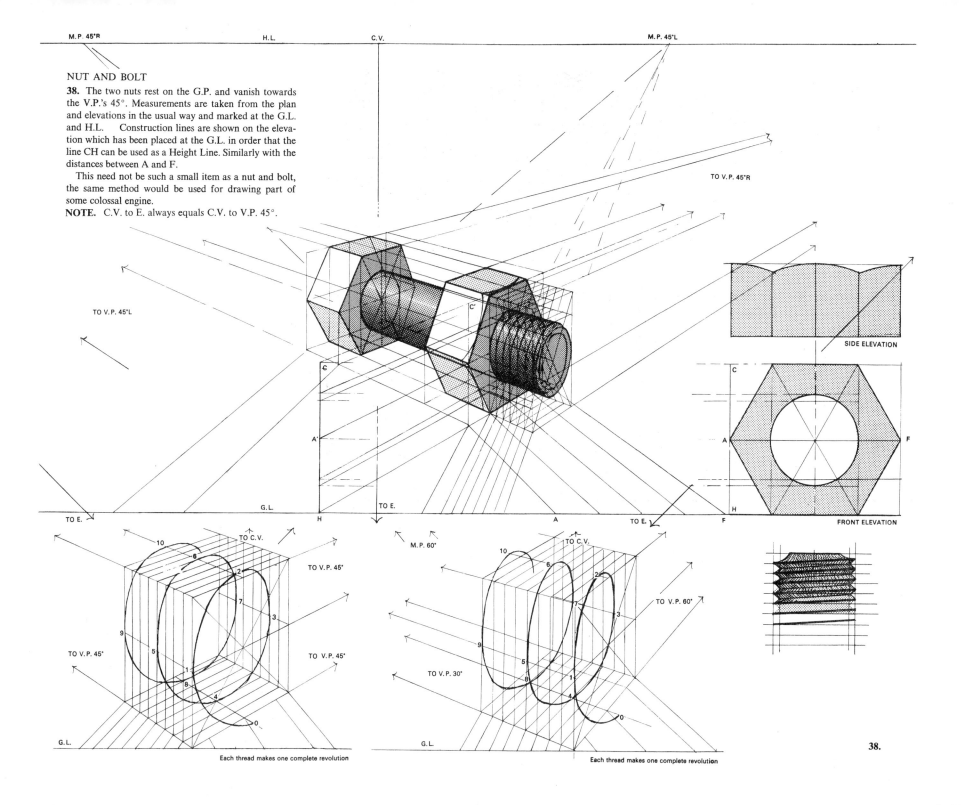

NUT AND BOLT

38. The two nuts rest on the G.P. and vanish towards the V.P.'s 45°. Measurements are taken from the plan and elevations in the usual way and marked at the G.L. and H.L. Construction lines are shown on the elevation which has been placed at the G.L. in order that the line CH can be used as a Height Line. Similarly with the distances between A and F.

This need not be such a small item as a nut and bolt, the same method would be used for drawing part of some colossal engine.

NOTE. C.V. to E. always equals C.V. to V.P. 45°.

TO V.P. 45°R

TO V.P. 45°L

SIDE ELEVATION

FRONT ELEVATION

G.L. TO E. TO E.

TO E. H

TO C.V.

TO V.P. 45°

TO V.P. 45°

TO V.P. 45°

TO V.P. 45°

G.L.

Each thread makes one complete revolution

M.P. 60°

TO C.V.

TO V.P. 60°

TO V.P. 30°

G.L.

Each thread makes one complete revolution

38.

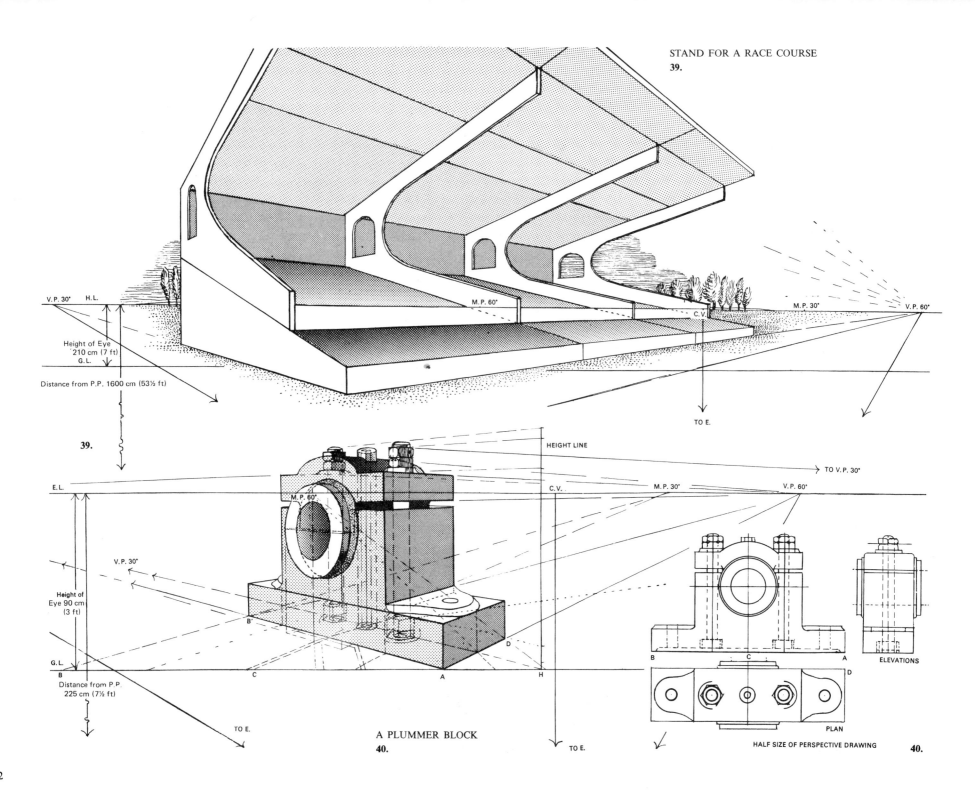

STAND FOR A RACE COURSE
39.

V.P. 30° H.L.

Height of Eye
210 cm (7 ft)
G.L.

M.P. 60°

M.P. 30° V.P. 60°

C.V.

Distance from P.P. 1600 cm (53½ ft)

TO E.

39.

HEIGHT LINE

TO V.P. 30°

E.L. C.V. M.P. 30° V.P. 60°

M.P. 60°

V.P. 30°

Height of
Eye 90 cm
(3 ft)

B'

D

G.L.

B C A H

Distance from P.P.
225 cm (7½ ft)

TO E.

A PLUMMER BLOCK
40.

TO E.

B C A

ELEVATIONS

B C D

PLAN

HALF SIZE OF PERSPECTIVE DRAWING **40.**

42

If possible, when teaching, take the students for a walk and point out the doorsteps at the front doors of the houses which have been built on the side of a hill. Show how the step itself is level where one treads but where the step meets the path, it is higher one end than the other. In other words the path goes either up or down, making an angle with the level plane.

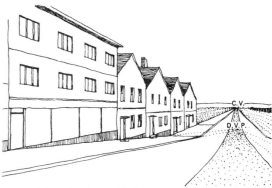

A long shop front will also show that the floor inside is level but the pavement runs downhill at an angle.

OBLIQUE PERSPECTIVE

This is a most interesting part in the study of perspective as it involves uphills and downhills, roofs, etc.

The first diagram shows a slanting roof receding directly away from the spectator in an upwards direction, with the lower edge nearer to the Picture Plane than the ridge line. This means that the slanting roof lies in an ASCENDING PLANE.

The far side of this roof has the ridge line nearer to the Picture Plane than the lower edge. This means that the roof is slanting downwards and that it lies in a DESCENDING PLANE.

These buildings are not parallel to the Picture Plane and the planes of their roofs recede at various angles. They are in oblique planes which are neither horizontal nor vertical to the Picture Plane but even so, their contact with the Picture Plane may be found and required distances measured along their Vanishing Lines.

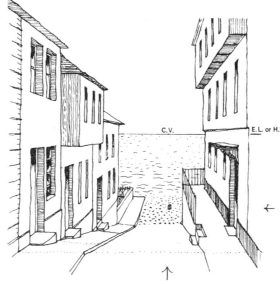

Here the downhill lines are vanishing towards the left-hand side of the base of the small post on the beach. All level lines receding from the P.P. are going towards the small mark on the Horizon immediately above.

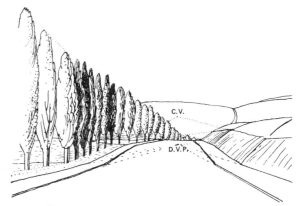

Even where there are no buildings it is still possible to depict a scene in which the ground is not level, and when drawing from memory or from imagination it is essential to know where the Vanishing Points should be. By understanding the following problems it will be possible to draw a road receding downhill directly away from you, a thing many a student would like to attempt in the first lesson on Perspective.

When doing illustrations, it is quite likely that the setting out of a perspective problem with the position of the Eye below, will never be used again. However, with this knowledge at the back of one's mind, an imaginative drawing will appear more convincing and a reconstruction of a ruin more realistic.

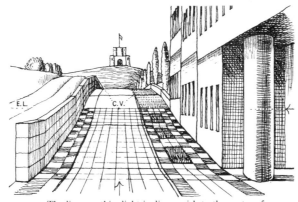

The lines on this slight incline vanish to the centre of the distant arch; the steeper ones are going to the tip of the flagstaff. The arrows point to the C.V. on the E.L.

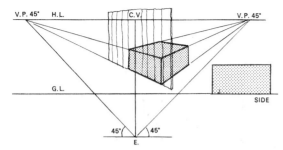

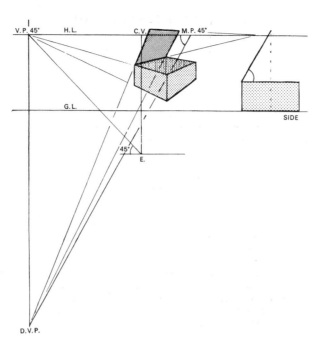

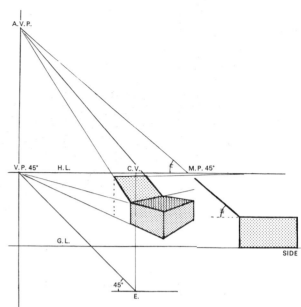

Supposing we have a box lying on the Ground Plane with the sides vanishing at 45° to the left and right. Take an actual box, the size will not matter, and place a stiff sheet of paper against the side.

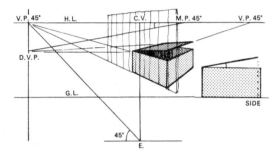

Now open the lid slowly. It will be seen that the side of the lid still touches the sheet of paper, and will go on touching it however far it is opened.

The wider the lid is opened, the farther down the Vanishing Point will go. The actual lid is said to lie in a Descending Plane.

But as the lid is opened wider still, beyond the vertical line, it will be seen that the side now vanishes to an ASCENDING VANISHING POINT. It still touches the sheet of paper held against the side.

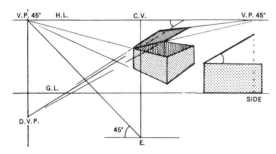

This shows that the side of the lid is contained in the same plane as the side of the box. As the box vanished to a point 45° to the left, a vertical line drawn down through this V.P. 45° will contain all the Vanishing Points for the direction of the sides of the opening lid.

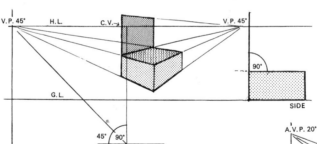

By opening wider, the side of the lid will eventually be a vertical line, the plane of the lid making an angle of 90° with the Ground Plane, and thus would be drawn by using Parallel Perspective.

Therefore at whatever angle the lid may be opened, the Vanishing Points are all contained in the vertical line drawn up and down through the V.P. of the box, and their respective angles can be measured at the M.P. for this V.P. on the H.L. as shown in the diagram below.

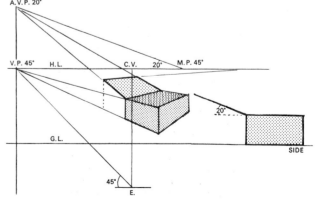

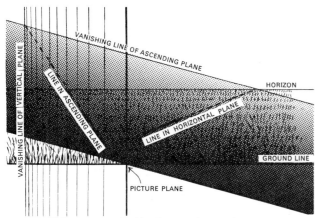

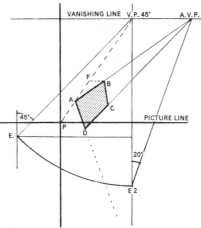

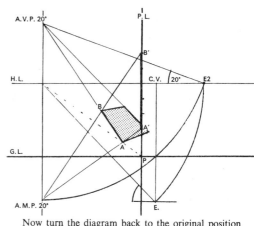

All lines are contained in planes, and every plane has a distant line containing the Vanishing Points, and a near line touching the Picture Plane on which measurements can be taken.

In Parallel and in Angular Perspective, the Ground Plane had a distant line known as the Horizon or Horizon Line, and a near line known as the Ground Line.

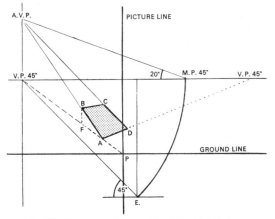

In this diagram we have a line AB which is in an Oblique Plane. The direction of the plane is towards the right V.P. 45° and the tilt towards the left V.P. 45° to an ascending point somewhere above it.

The distant line of these Ascending Vanishing Points will be a vertical line drawn through the left V.P. 45°. The angles for the tilt will be measured at the M.P. 45° for this V.P. In this diagram 20°.

To obtain the near line touching the P.P. follow forward from the V.P. 45° through F and A to meet the G.L. at P.

Because the Vanishing Line of the Plane was a vertical line, the near line drawn up through P will also be a vertical line. It is known as the PICTURE LINE and actual measurements may be taken on it with a ruler.

Suppose we turn the diagram on its side – it will appear like this –

We have a Vanishing Line corresponding to an Horizon Line, a Picture Line corresponding to a Ground Line, and we also have a point at which the angle of the incline was measured. This point corresponds to point E. and will be known as E2. Angles for the Oblique Plane will be measured at E2.

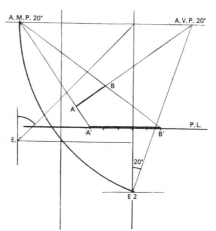

You will remember the rule to find a M.P. for a V.P. Take the distance of the V.P. to E. and with this as radius, describe an arc cutting the line containing the V.P. and this point will be the M.P. required.

In this case – take the distance of the A.V.P. to E2, and with this as radius, describe an arc cutting the line containing the V.P. and this will be the A.M.P. required, i.e. the ASCENDING MEASURING POINT.

In order to use it, come forward from the A.M.P. through A to touch the P.L. at A′, and through B to touch the P.L. at B′, and A′B′ will be the actual length of AB on the inclined plane.

Now turn the diagram back to the original position and we have this –

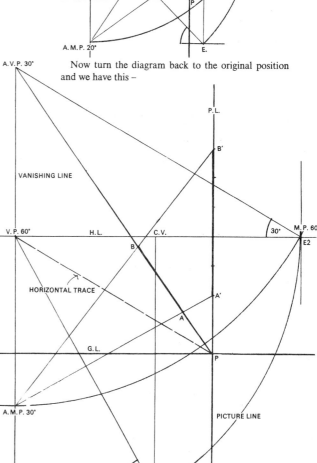

Here AB is 150 cm (5 ft) long in perspective, and is in an Ascending Plane of 30° with the Ground Plane. The line from the V.P. 60° to P, is known as the HORIZONTAL TRACE. In the top diagram, it is the dotted line.

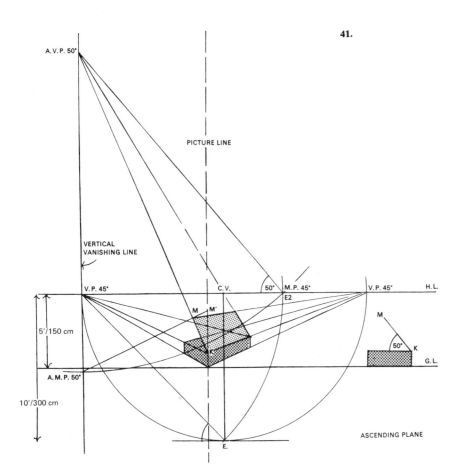

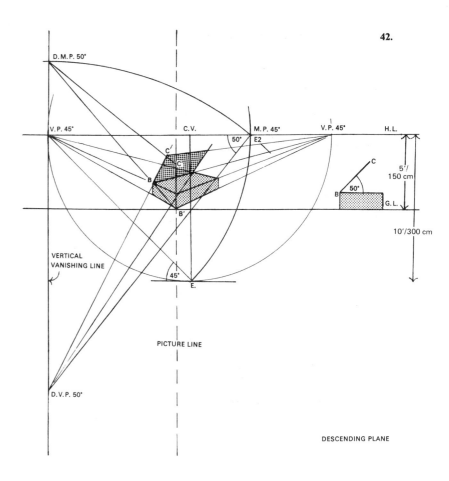

Examples.

AN ASCENDING PLANE

41. Height of Eye 150 cm (5 ft).

Distance from P.P. 300 cm (10 ft).

This is the method for using the new M.P.'s.

Assume that the basic diagram has been drawn with a box on the Ground Plane, and that we have to put on a lid which is opened at 50°.

If the lid were closed the sides would vanish to the V.P. 45°, therefore as it is opened it will vanish to a point above this V.P., for it lies in an Ascending Plane.

Find the M.P. 45° and use this point as E2. At E2 make an angle of 50° *above* the H.L. and produce it to meet the Vertical Vanishing Line drawn through the V.P. 45°. This will give the ASCENDING V.P. 50°.

Take the short sides of the lid back towards this point.

Next find the A.M.P. for this A.V.P. Take the distance from A.V.P. 50° to E2, and with this V.P. as a centre, and the distance to E2 as radius, describe an arc

cutting the Vertical Vanishing Line. This point will be the A.M.P. 50°, the ASCENDING MEASURING POINT.

As K already touches the Picture Line, measure the width of the lid up this line to M′, and return it to the A.M.P. 50°, cutting the line from K to the A.V.P. at M. Thus KM is the required width of the lid.

A line from M to the right V.P. 45° will give the long edge of the lid, and a line from the other hinged corner to the A.V.P. will give the other short side of the lid.

A DESCENDING PLANE

42. Now turn the box around and have the hinge on the far side. It will be seen that the lid now lies in a Descending Plane. Therefore the 50° must be measured *below* the E2 on the H.L. and not above.

Produce this angle to meet the Vertical Vanishing Line at the D.V.P. 50°, i.e. the DESCENDING VAN-

ISHING POINT, and take the sides of the lid down to this point from the back of the box.

The M.P. for this D.V.P. is found in the usual manner. With D.V.P. as a centre, and the distance to E2 as radius, an arc is described to cut the Vertical Vanishing Line. This point is the D.M.P. 50°, the DESCENDING MEASURING POINT.

From here come forward through B to touch the P.L. at B′. (In this diagram B′ accidently coincides with the bottom of the box.) Measure the width of the lid up the P.L. from B′ giving C′.

From here return to the D.M.P. 50°, cutting the line from the D.V.P. produced, at point C. This is the point required.

Take a line from the D.V.P. 50° through the far corner of the box lid, and produce this line to cut the line from C to the V.P. 45°.

Thus the lid is complete.

A SQUARE IN A DESCENDING PLANE

43. Height of Eye 150 cm (5 ft).
Distance from P.P. 270 cm (9 ft).

ABCD is a 90 cm (3 ft) square lying in a Descending Plane of 45° with the Ground Plane. A is 45 cm (1½ ft) to the right of the spectator and 105 cm (3½ ft) beyond the P.P. AB lies on the Ground Plane and recedes to the right V.P. 30°.

Draw the basic diagram and find A by using the C.V. **and the V.P. 45° to the right. Draw the line AB towards the right V.P. 30°.**

Bring A to the front from the M.P. 30° to touch the G.L., measure 90 cm (3 ft) towards the right on the G.L., and go back to the M.P. 30° thus finding point B on the line from A to the V.P. 30°.

Had the square lain flat instead of being tipped, because one side vanished at 30° to the right, two sides would have vanished to the V.P. 60°. Therefore find the V.P. 60° and draw a vertical line through this point.

Find the M.P. 60° because this will be used as the E2.

At E2 measure 45° below the H.L. and produce it to meet the vertical line through the V.P. 60°, and this point will be the D.V.P. 45°, i.e. the Descending Vanishing Point for the plane of the square.

Next find the D.M.P. for the D.V.P. With the D.V.P. as a centre and the distance from it to E2 as radius, describe an arc to cut the Vertical Vanishing Line. Where it cuts will be the D.M.P. 45°.

A line brought forward through A from the V.P. 60° to meet the Ground Line will give the Horizontal Trace. Where the H.T. meets the G.L. is point P, and through point P draw the vertical Picture Line for actual measurements.

From the D.M.P. come forward through A to meet this line at K, and from K measure 90 cm (3 ft) up the vertical line, and take a line back to the D.M.P.

Where this line cuts the line A produced from the D.V.P. will be point D. From D vanish to the V.P. 30° cutting the line produced up through B at point C, thus completing the required square, ABCD.

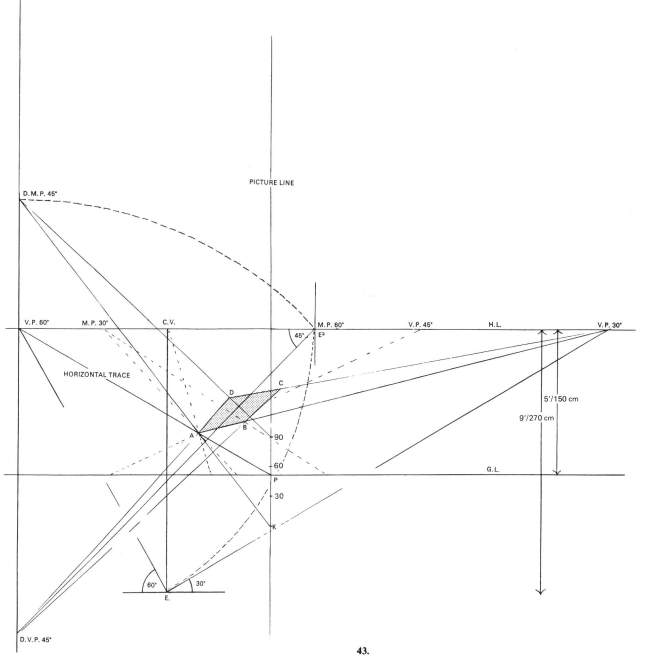

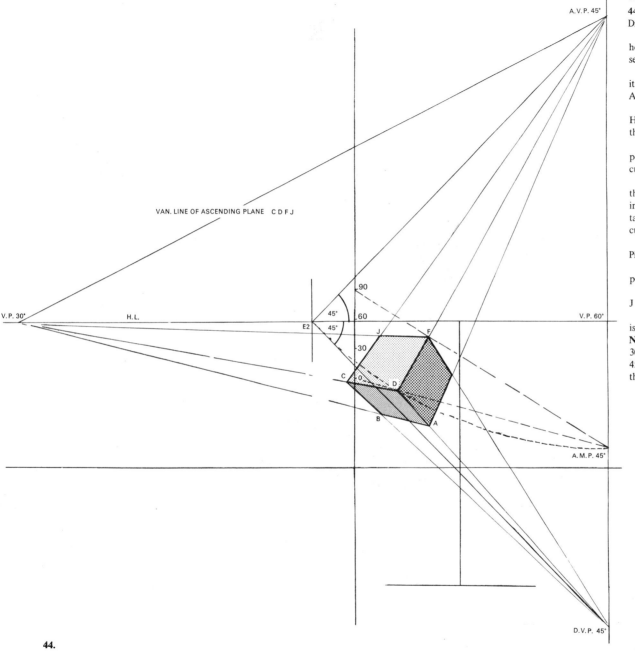

A.V.P. 45°

VAN. LINE OF ASCENDING PLANE C D F J

90

45° 60

V.P. 30° H.L. 45°

E2 45°

30

J F

C 0 D

B A

V.P. 60°

A.M.P. 45°

D.V.P. 45°

A CUBE WITH FACE CDFJ LYING IN AN ASCENDING PLANE

44. Height of Eye 150 cm (5 ft).
Distance from P.P. 270 cm (9 ft).

This cube is based on the preceding diagram, and by holding the page towards the light, one of the faces is seen, i.e. the face ABCD.

As this face ABCD lies in a Descending Plane of 45°, it follows that the faces at right-angles to this, will be in Ascending Planes of 45°.

Therefore at E2 measure an angle of 45° above the H.L., and produce to meet the Vertical Vanishing Line through the V.P. 60°.

Lines are then taken up towards this A.V.P. from the points ABCD, thus giving the direction of the tilt of the cube.

To measure up these lines an A.M.P. will be needed, therefore find the A.M.P. 45° in the usual manner, using E2, the A.V.P. as the centre of a circle, and the distance from the A.V.P. to E2 as radius. Where this arc cuts the Vertical Vanishing Line is the A.M.P. 45°.

From the A.M.P. come forward through D to meet the Picture Line and up this line measure 90 cm (3 ft).

From this point return to the A.M.P. thus finding point F on the line from D to the A.V.P.

A line from F to the left-hand V.P. 30° will find point J on the line from C to the A.V.P.

From F take a line down to the D.V.P., and the cube is complete.

NOTE. The direction of the plane CDFJ is to the V.P. 30° on the H.L., and the tilt of the plane is to the A.V.P. 45°. By taking a line through these two V.P.'s we obtain the Vanishing Line of the plane CDFJ.

44.

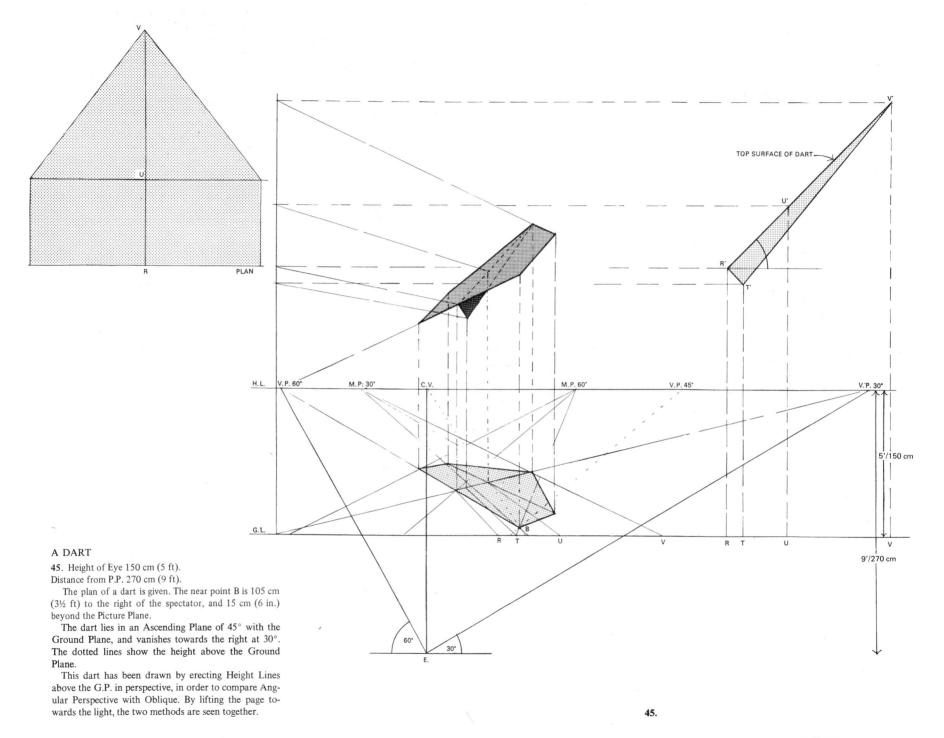

A DART

45. Height of Eye 150 cm (5 ft).
Distance from P.P. 270 cm (9 ft).

The plan of a dart is given. The near point B is 105 cm (3½ ft) to the right of the spectator, and 15 cm (6 in.) beyond the Picture Plane.

The dart lies in an Ascending Plane of 45° with the Ground Plane, and vanishes towards the right at 30°. The dotted lines show the height above the Ground Plane.

This dart has been drawn by erecting Height Lines above the G.P. in perspective, in order to compare Angular Perspective with Oblique. By lifting the page towards the light, the two methods are seen together.

45.

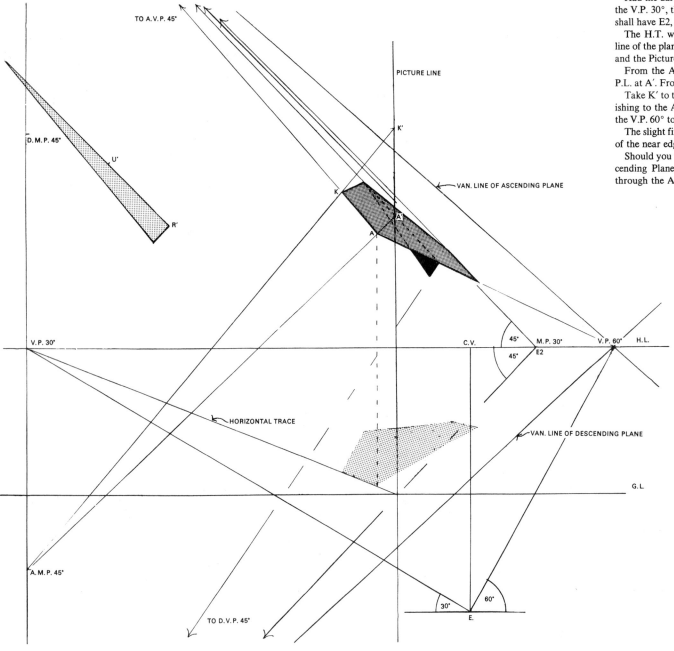

The dotted line shows how the near side of the dart has been taken up from the G.P. to find point A.

Had the dart lain flat, it would have vanished towards the V.P. 30°, therefore it will be at the M.P. 30° that we shall have E2, and the angles of 45° constructed.

The H.T. will be brought forward through the near line of the plan of the dart on the G.P., to meet the G.L., and the Picture Line erected at this point.

From the A.M.P. 45° come through A to meet this P.L. at A'. From A' measure up A'K' equal to R'U'.

Take K' to the A.M.P. cutting the line of the dart vanishing to the A.V.P. at K. Take a line from K down to the V.P. 60° to find the point for the far edge of the dart.

The slight fin is found by taking a line from the centre of the near edge down to the D.V.P. 45°.

Should you wish to find the Vanishing Line of the Ascending Plane, take a line through the V.P. 60° and through the A.V.P. 45°.

TO A.V.P. 45°

PICTURE LINE

D.M.P. 45°

U'

R'

K'

K

VAN. LINE OF ASCENDING PLANE

A'

A

V.P. 30°

C.V.

45°

45°

M.P. 30°

E2

V.P. 60°

H.L.

HORIZONTAL TRACE

VAN. LINE OF DESCENDING PLANE

G.L.

A.M.P. 45°

30°

60°

E.

TO D.V.P. 45°

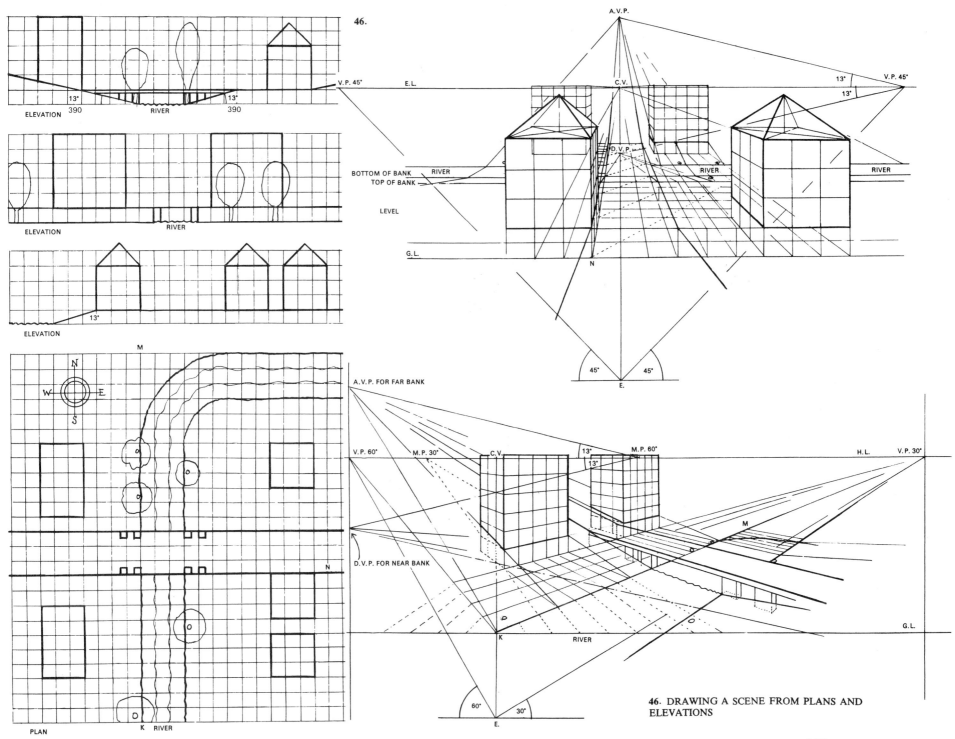

46.

V.P. 45°

A.V.P.

E.L.

C.V.

D.V.P.

13°

V.P. 45°

13°

ELEVATION 390 RIVER 390

BOTTOM OF BANK RIVER

TOP OF BANK

LEVEL

RIVER RIVER

ELEVATION RIVER

G.L.

N

ELEVATION 13°

45° 45°

E.

M

A.V.P. FOR FAR BANK

V.P. 60° M.P. 30° C.V. 13° M.P. 60° H.L. V.P. 30°

13°

D.V.P. FOR NEAR BANK

N

M

K RIVER

G.L.

PLAN K RIVER

60° 30°

E.

**46. DRAWING A SCENE FROM PLANS AND
ELEVATIONS**

A lift-up page

51

52 A lift-up page

TO MAKE A LION FLY
Construction used in B.B.C. T.V. story.

47. First find the centre of the toy animal, and having decided on the size of the wings, construct a rectangle AHMG so that the diagonal lines of its base pass through the centre lines of the animal. (Shown here by dotted lines.)

On the rectangle AHMG erect height lines FJKL, and within the rectangle AFLG construct a curve and arrange the front tips of the wings along it. Use the V.P. for lines AG and FL for plotting the points on the curve.

Take lines back from the front tips of the wings using the V.P. for the lines FJ and LK. These lines will meet a curve drawn within the rectangle HJKM.

From these wing tips, the radiating lines are drawn down to point C for the front of the wings, and down to point C' for the backs of the wings. A small curve can be marked where the wings meet the animal's body. The line CC' is immediately below the line BB' which passes through the centre of the rectangle AHMG.

When making drawings for animation many new problems will arise, but they can often be solved by a knowledge of perspective, especially when it is impossible to construct a model.

Here, tracings were taken of each pair of wings and the result cut out in cardboard.

During production, each pair was laid on the drawing and then photographed. This was done until all five pairs were used in turn, and then back again in reverse. This gave one flap of the wings and the process was continued.

The cut-out lion was moved forward slightly for each new position to be photographed across a painted background.

All this was well worth the effort when one watched the television programme and saw the lion flying realistically from tree to tree.

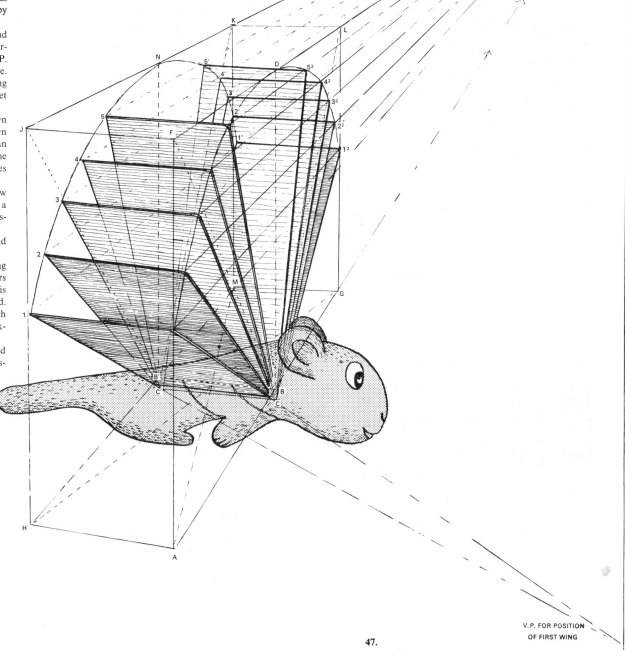

TO V.P. FOR WING TIPS

V.P. FOR POSITION
OF FIRST WING

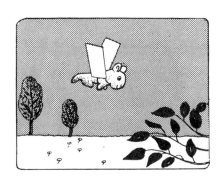

47.

53

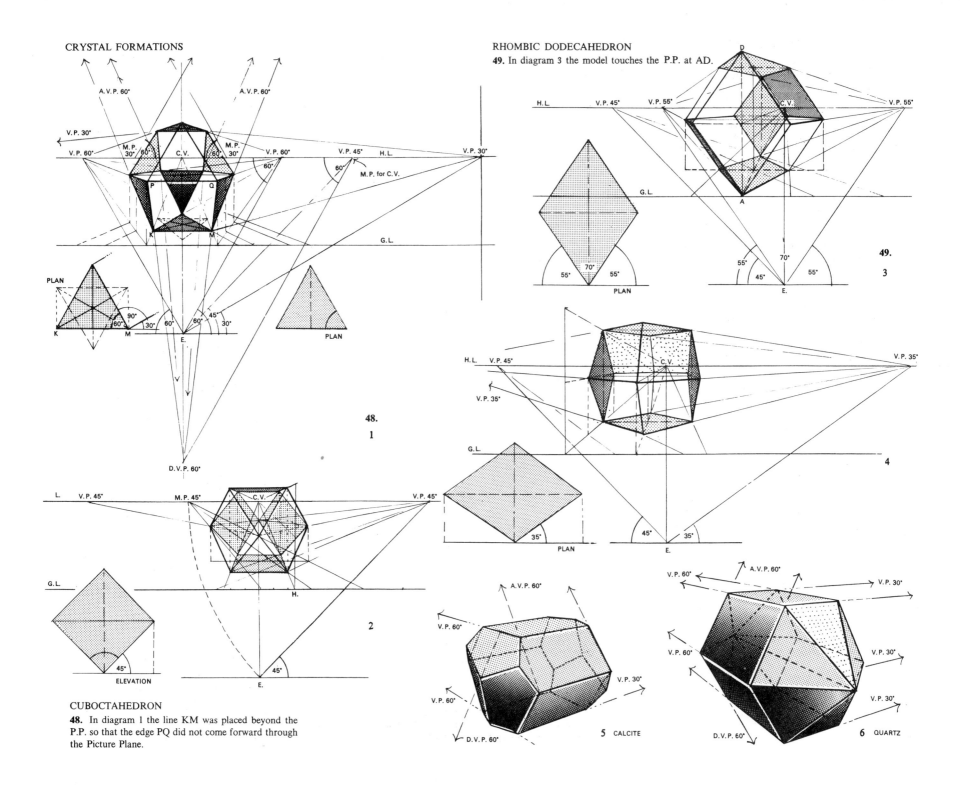

CRYSTAL FORMATIONS

RHOMBIC DODECAHEDRON

49. In diagram 3 the model touches the P.P. at AD.

48.

1

49.

3

4

CUBOCTAHEDRON

48. In diagram 1 the line KM was placed beyond the P.P. so that the edge PQ did not come forward through the Picture Plane.

2

5 CALCITE

6 QUARTZ

SHADOWS

Where a drawing is apt to appear flat, the addition of shadows will give it a feeling of depth.

A study of these will make a student more observant, especially where shadows come in contact with other objects. The shadow of a porch over a door will show the contour of the porch outlined on the wall, in fact shadows will reveal forms which are quite lost in the light.

A dark sky behind a group of buildings will add depth to a scene should the buildings be of a pale colour.

Shadows of chimneys cast on roofs are very interesting for from these it is possible to obtain the position of the sun. How often when out-of-doors the sun disappears and the shadows are lost. If one knew where the sun was, then these shadows may be added later.

Sometimes a roof may be wet, or perhaps the reflection of a chimney is more pronounced than the shadow, for with rain and sunshine, as during an April shower, it is possible to see both reflection and shadow at the same time.

Another interesting sight is that on a cold morning, when the sun has melted the frost on a roof except in those parts where the shadows fall, so that these shadows which are white appear lighter than those parts of the roof where the sun has shone.

An evening walk along a road with the lamps lit gives one a feeling that the shadows are following one around. As one passes one bright light and goes towards the next lamp-post, a fresh shadow formed by this new light appears, and gradually the old shadow is left behind.

Watch the shadows on the surface of the water when leaning over a bridge, and then forget the surface and look down into the depths and study the reflections only. Put the two together and the scene becomes most intriguing.

Simple shadows may be pointed out to young children and even added to their drawing lesson, but naturally shadows on Oblique surfaces should not be attempted. Even the advanced students must not start these until the problems in Oblique Perspective have been understood.

As the Sun is 150 million kilometres or about 92 million miles away from the Earth, the rays which reach us can be assumed to be parallel to one another. This is shown in the diagram at the top of the page.

Two factors will govern shadows: firstly the direction, which depends on the position of the Sun, and secondly the length, which depends on the height of the Sun. In order to cast shadows we must know both these things.

SUN IN THE PICTURE PLANE

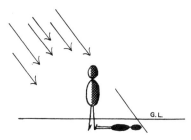

Supposing the Sun was high up on our left or high up on our right in such a position that if the Picture Plane were large enough, it could be marked on it. The rays coming down towards the Earth would make our own shadow parallel to the Ground Line.

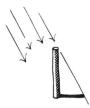

So when the Sun is due West, the shadows of objects on the Ground Plane will lie due East, and

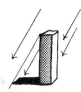

when the Sun is in the East, the shadows will go towards the West, and in both of these positions, the shadows can be drawn by using a T-square.

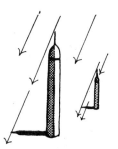

Now, if the Sun is high up in the sky towards the right, the shadows come steeply down, thus giving short shadows towards the left.

If the Sun is low in the sky on the right, the rays come down at a lower angle, and the shadows towards the left are longer.

When the rays come down making an angle of 45° with the Ground Plane, then the shadows are equal in length to the height of the objects casting the shadows.

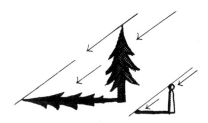

It will now have been observed that when the Sun is in the Picture Plane, whether to the right or to the left, and whether high up or low down, all the shadows may be drawn by using a set-square and T-square. This is the easiest position for the Sun to be in, and in this case children can quite well add shadows to their drawings.

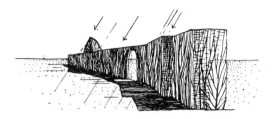

If the object casting the shadow is at all complicated, vertical lines can be dropped at convenient places, the shadows of these cast, and the various extremities joined.

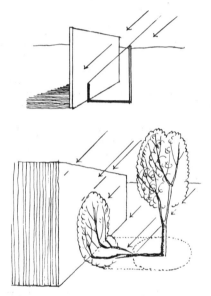

When the shadow from a vertical line meets a vertical surface which is at right-angles to the Picture Plane, then the shadow will continue up this plane until a ray from the Sun cuts off the length.

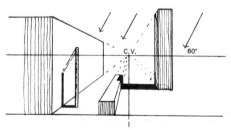

Here the Sun is in the Picture Plane, the rays coming down from the right at 60°.

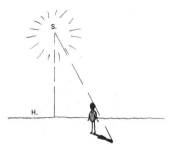

Supposing the Sun is in front of the spectator and is beyond the Picture Plane. This means that the spectator's own shadow will fall behind him, and that the shadows will come away from the horizon.

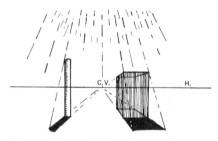

If the Sun is immediately in front, it will be over the C.V. whatever the altitude, and the direction of the shadows will come away from this point.

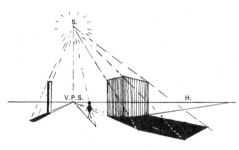

Wherever the Sun is beyond the Picture Plane, a point can be found under it, anywhere along the Horizon, and it is from this point that the shadows will come forward towards the Picture Plane.

The point where this vertical ray taken down from the Sun hits the Horizon is known as the V.P.S., i.e. the VANISHING POINT OF THE SHADOWS, for all shadows of verticals on the Ground Plane will appear to come from here.

Therefore as the shadows appear to come from a single point on the Horizon, they could be said to meet at this point, and therefore are parallel one to another.

By taking a line from the V.P.S. through the base of a vertical line, the direction of its shadow is obtained. A ray from the Sun through the tip of the vertical line will cut off the length of the shadow.

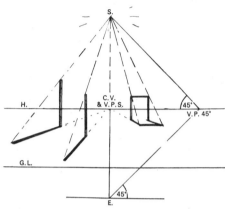

In the above diagram the Sun is beyond the Picture Plane and immediately above the C.V. at an altitude of 45°. This measurement is taken at the V.P. 45°, i.e. the M.P. for the C.V. A ray from the Sun taken vertically down on to the Horizon gives the V.P.S. (In this case coinciding with the C.V.)

The shadows spread out from this point, and the rays from the Sun give the length of the shadows.

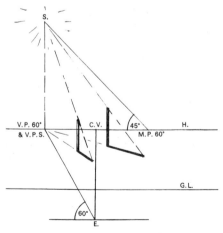

Here the Sun is beyond the P.P. but slightly towards the left of the C.V. at an angle of 60°. The altitude of 45° is taken up from the M.P. 60°.

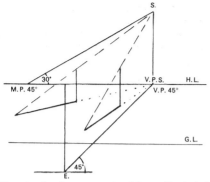

Here the Sun is away to the right at 45°. It is low above the Horizon at an altitude of 30°. This altitude is put above the H.L. at the M.P. 45° and the angle produced to meet the vertical taken up from the V.P. 45°, thus giving the Sun's position.

The shadow of the post spreads forward from the direction of the V.P.S., and its length is cut off by a ray from the Sun.

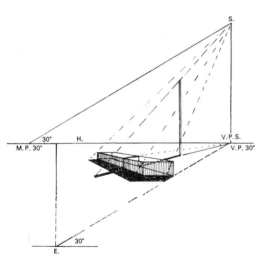

When a shadow from a vertical line meets a vertical plane, continue the shadow up the plane, then along the Horizontal Plane from the V.P.S., down the shadow side and along the G.P. to meet the ray from the Sun. In this diagram the Sun is towards the right at 30° and the altitude is also 30°.

SUN BEHIND THE SPECTATOR

Because the Sun is so far away, and the rays are considered to be parallel to one another, it means that if the Sun were exactly behind you, your shadow would vanish to your own Centre of Vision.

The shadows of vertical posts and of trees, etc. would also vanish towards your C.V.

If the Sun is behind us, we cannot mark it on the paper, but we *can* mark the point at which the shadows appear to vanish. This is the point we shall find and use.

We know that lines which are parallel to one another appear to meet at a point. The few rays of the Sun which meet the Earth, being parallel to one another, will also meet at a point.

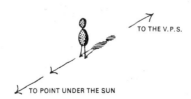

When the Sun is behind you on the left, the shadows go towards the right, and when the Sun is behind you on the right, the shadows will go towards the left.

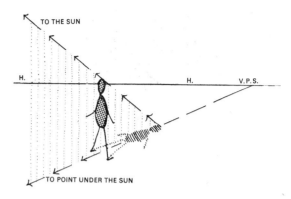

With the Sun behind on our left, suppose we continue our shadow towards the right, in a straight line till we meet the Horizon. This point would be the V.P.S., the Vanishing Point of Shadows on the Ground Plane. If we continue back from this point along through our shadow, we would be pointing towards the direction of the Sun.

Now, if we took a line from the tip of our shadow, back through the top of our head, and produced it on, it would be pointing towards the Sun itself. The angle it made with the Ground Plane would give the altitude of the Sun. Therefore we must be able to measure this angle.

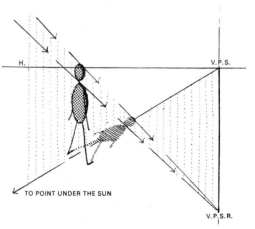

The parallel rays of the Sun come down through the tops of the objects and the tips of their shadows to meet at a point under the V.P.S. This point will be known as the V.P.S.R., i.e. the VANISHING POINT OF THE SUN'S RAYS, and we shall find it on the paper *below* the Horizon.

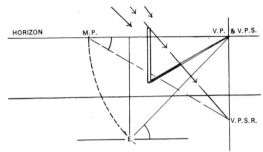

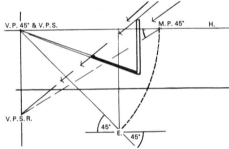

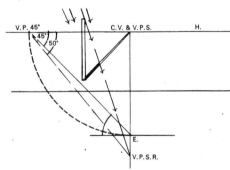

You will remember that the altitude of the Sun was measured at the M.P. for the V.P. of its direction, and we shall use this M.P. again. Instead of putting the angle above the Horizon at this point, we shall now measure it below. A line from the M.P. to the V.P.S.R. will give the angle at which the rays come down.

Here the Sun is behind the spectator's right, making an angle of 45° with the P.P. The altitude of the Sun is 30°. The direction of the shadow will go towards the left V.P. 45°, away from the Sun and an angle of 30° put at the M.P. 45° below the H.L. This is continued to meet the vertical drawn through the V.P. and will give the V.P.S.R. A ray through the top of the post to the V.P.S.R. will cut off the length of the shadow.

Here the Sun is immediately behind, which means that the shadows will converge towards the C.V., therefore the M.P. for the C.V. is used, i.e. the V.P. 45°. The altitude of the Sun is 50°.

SHADOWS ON INCLINED PLANES

When shadows fell on the flat Ground Plane their Vanishing Points were found on the Horizon or Horizon Line, i.e. the Vanishing Line of the plane on which the shadows fell.

If the shadow of a vertical line should fall on an inclined plane, we must find the Vanishing Line of the inclined plane which is to receive the shadow.

To find the Vanishing Line of any plane, take a line through any two of its Vanishing Points and produce the line in either direction.

A vertical ray dropped from the Sun to meet this Vanishing Line will give the Vanishing Point for the shadows on that plane, and a ray from the Sun through the top of the object will cut off the length of the shadow as before.

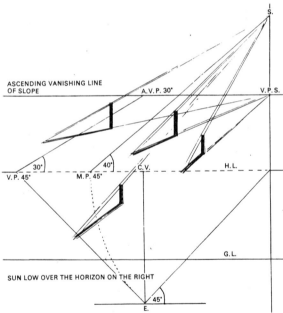

SUN LOW OVER THE HORIZON ON THE RIGHT

In this diagram the posts stand on a plane which vanishes in an upward direction immediately away from the spectator, ascending at an angle of 30°.

The Sun is low over the Horizon towards the right at 45° with the P.P. and at an altitude of 40°.

A vertical ray from the Sun is dropped on the Vanishing Line of the inclined plane to give the V.P.S. A line from the V.P.S. through the bases of the posts gives the direction of their shadows, and rays from the Sun cut off each length.

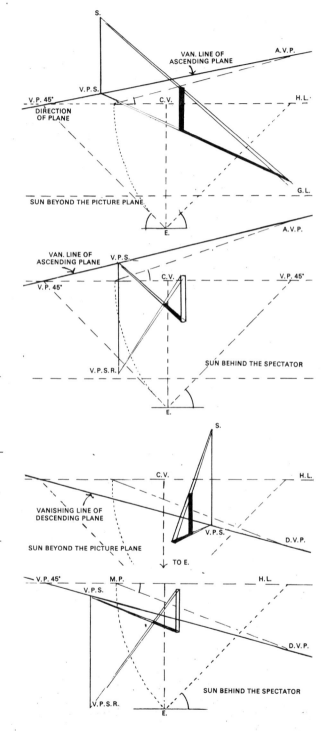

SUN BEYOND THE PICTURE PLANE

SUN BEHIND THE SPECTATOR

SUN BEYOND THE PICTURE PLANE

SUN BEHIND THE SPECTATOR

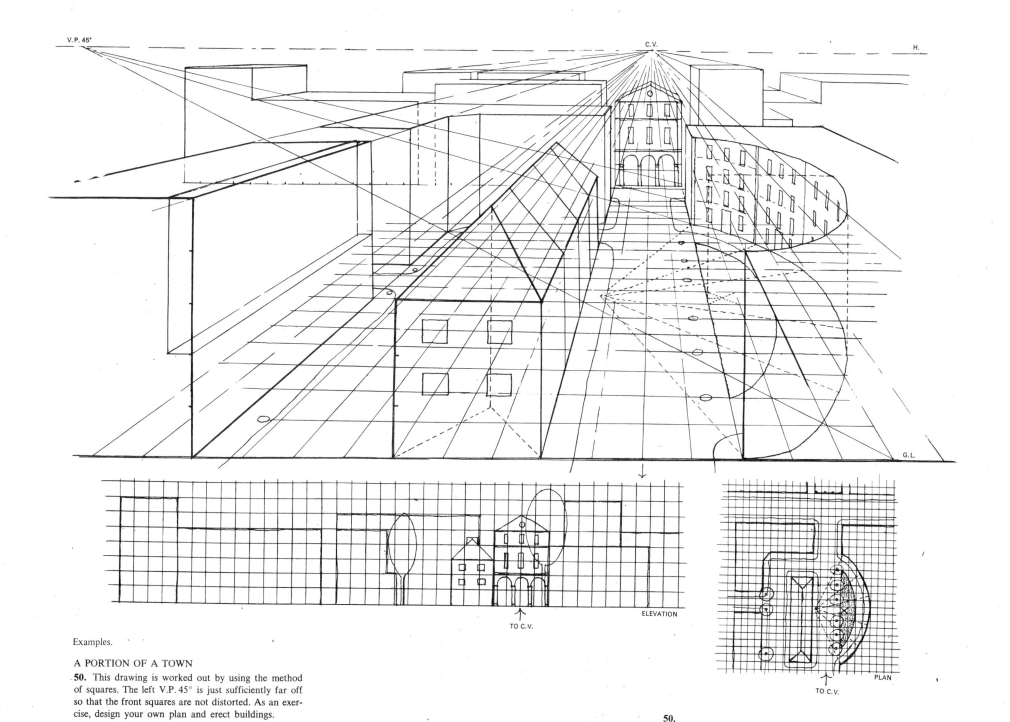

V.P. 45°

C.V.

H.

G.L.

ELEVATION

TO C.V.

PLAN

TO C.V.

Examples.

A PORTION OF A TOWN

50. This drawing is worked out by using the method of squares. The left V.P. 45° is just sufficiently far off so that the front squares are not distorted. As an exercise, design your own plan and erect buildings.

50.

A lift-up page

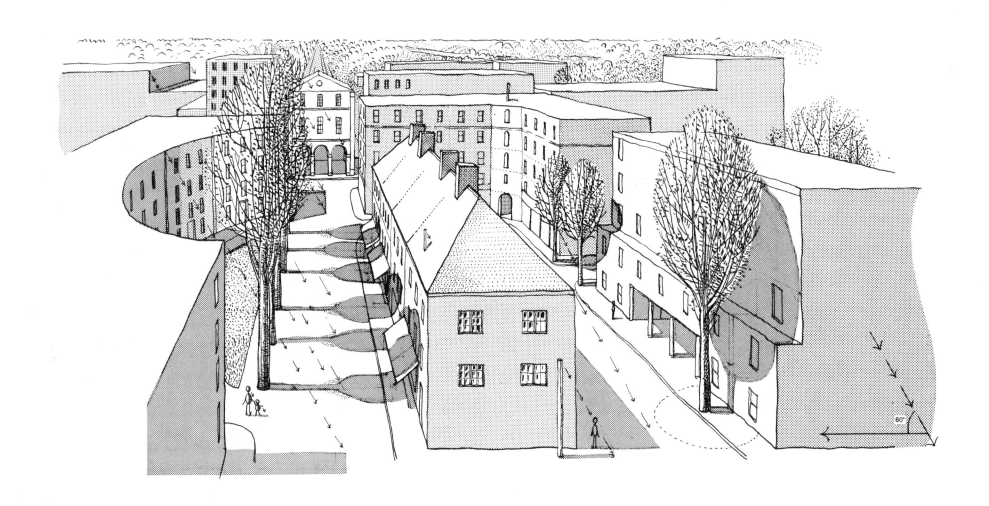

SUN IN THE PICTURE PLANE
Rays coming down at 60° with the G.P., from the left.

A lift-up page

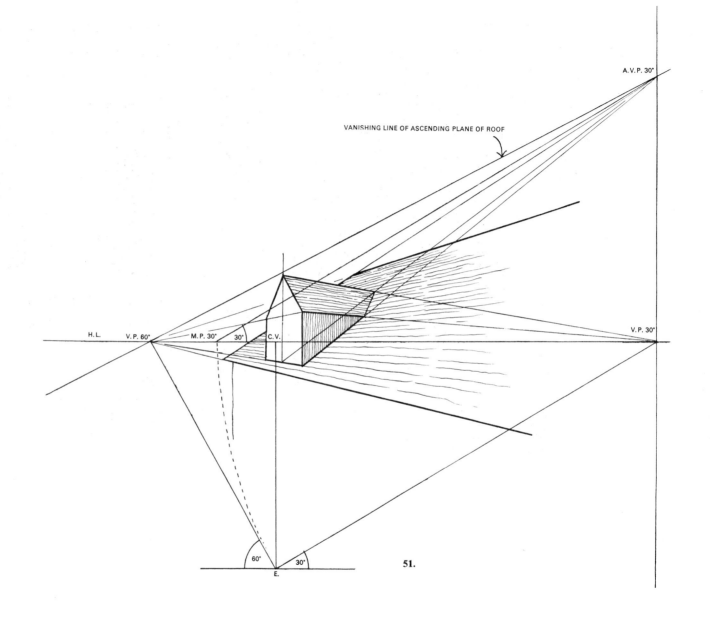

A.V.P. 30°

VANISHING LINE OF ASCENDING PLANE OF ROOF

H.L. V.P. 60° M.P. 30° 30° C.V. V.P. 30°

60° 30°
E.

51.

A DORMER WINDOW

51. The window and roof, etc. are drawn by Oblique
Perspective, and by holding the page towards the light,
the shadow of the dormer window on the sloping roof
is shown.

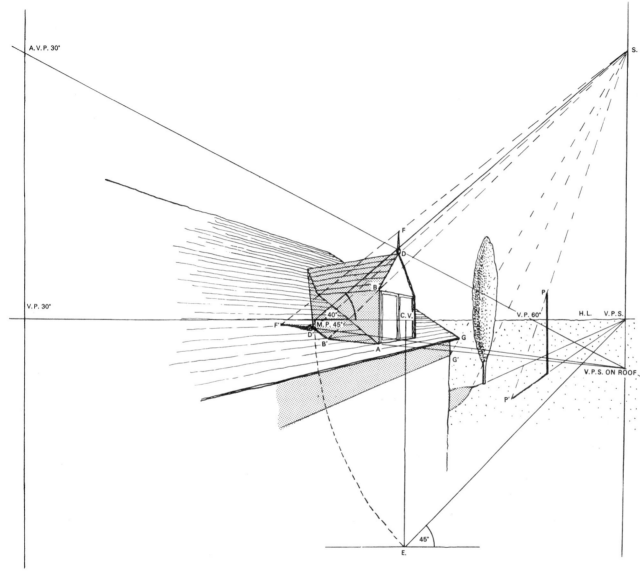

THE SHADOW ON THE ROOF
OF A DORMER WINDOW

The Sun is beyond the Picture Plane making an angle of 45° to the right of the spectator. The rays come down at an angle of 40° with the Ground Plane.

The Vanishing Line of the Ascending Plane of the roof is produced so that a vertical ray taken down from the Sun may fall on it, thus giving the Vanishing Point of Shadows on the roof, i.e. those cast by vertical lines.

Starting with the near vertical edge of the window, take a line back from this V.P.S., through A along the roof.

A ray from the Sun through B will cut this line at B', which will be one of the first points of the shadow.

Next find the shadow of a vertical line taken down through the centre of the window, in the same way. From the V.P.S. go back along the roof from the base of the centre line, and a ray from the Sun through the apex will cut this line, and thus give a second point for the shadow on the roof.

A ray from the Sun through the tip of the little post will also cut this line and give the shadow of the post on the roof.

From B' take a line to this apex shadow, and also a line from the apex shadow, back up the roof to the place where the dormer roof intersects the house roof. Thus the shadow is complete.

As the gable end has no projecting eave, a ray from the Sun taken down through the eave to touch the wall will give a point on the wall from which a line can be taken back along the wall, and the shadow under the eaves obtained.

SUN IN FRONT OF SPECTATOR

A lift-up page

SHADOW OF A CHIMNEY ON A SLOPING ROOF

52. Height of Eye 480 cm (16 ft).
Distance from P.P. 750 cm (25 ft).

The Sun is beyond the P.P. at an altitude of 50°. The direction is 43° with the P.P. towards the left.

First find the position of the Sun on the paper, assuming that the roof and chimney have already been drawn.

Make an angle of 43° at point E. to find the V.P. 43° on the H.L. to the left. Also find the M.P. 43°. At this M.P. measure the angle for the altitude of the Sun, i.e. 50°, and produce it to meet the vertical line taken up through the V.P. 43°. Where the two lines meet will be the position of the Sun.

Continue the vertical line down from the Sun through the V.P. 43° until it meets the line through the A.V.P. 35° and the V.P. 60° produced. Where the two lines meet is the Vanishing Point for shadows of vertical lines on the roof.

Rays from the Sun will cut off the lengths of the shadows.

For example, to plot the shadow of line DA. From this V.P.S. take a line back through A along the roof, a ray from the Sun through D will cut this line at D′, thus giving the length of the shadow.

To find the shadow of the vertical line marked F.

Take a line from A up the roof, following the intersection of the chimney with the roof towards the A.V.P. 35° of the roof plane, cutting the vertical from F at B.

The reason for doing this is because a vertical from F taken down to intersect the roof meets the roof on the other side of the ridge line, i.e. on the Descending Plane away from us. By continuing the intersecting line up from A, we are able to have point B on this side of the roof, and to cast the shadow for FB as we did for DA.

A line from the V.P.S. for shadows on the roof plane, continued up through B and produced, will meet a ray from the Sun through F at F′. Thus F′B is the shadow for FB.

By joining D′ to F′ we get the shadow of the horizontal line of the chimney DF.

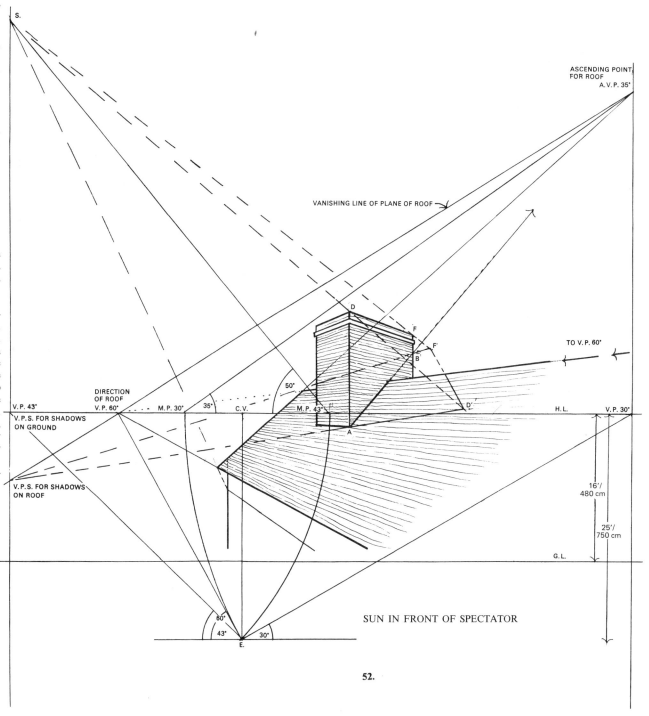

SUN IN FRONT OF SPECTATOR

52.

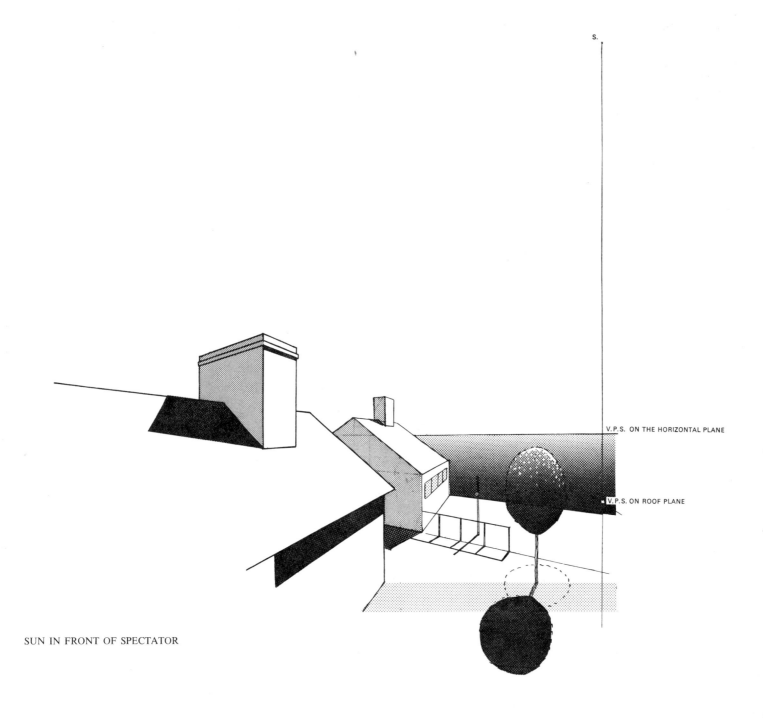

S.

V.P.S. ON THE HORIZONTAL PLANE

V.P.S. ON ROOF PLANE

SUN IN FRONT OF SPECTATOR

A lift-up page

THE SHADOW OF A SLANTING POLE

53. Height of Eye 172 cm (5¾ ft).
Distance from P.P. 285 cm (9½ ft).

The Sun is behind the spectator a little to the right at an angle of 15°, therefore the shadows will vanish towards the left V.P. 75°. (75+15=90). This is the V.P.S.

The altitude of the Sun is 45°, therefore this is measured *below* the H.L. at the M.P. 75°, and taken to meet the vertical line drawn down from the V.P.S. This is the V.P.S.R.

The slanting pole FD leans against a building which recedes towards the right at 30°. P is the point where the pole touches the eave line. Between D and P take any point A from which to drop a vertical line.

Cast the shadow of this vertical which touches the ground at A′. Take A′ back to the V.P.S. on the H.L., and a ray through A down to the V.P.S.R. will cut this line at B.

Continue DB to meet the wall, and a line up to P will give the shadow of the line DP.

The rest of the shadow lies on the roof, therefore the Vanishing Line of the Plane of the roof will be needed. A vertical line drawn up to this Vanishing Line from the V.P.S.R. will give the V.P.S. of vertical lines on the roof.

Again we shall need a vertical line. From P take a line up to the A.V.P. 40° of the roof, and drop a vertical line from F to meet this line at F′.

The shadow of the vertical line FF′ will be a line from F′ taken up the roof to the Ascending V.P.S. A ray taken down through F to the V.P.S.R. will cut this line at J, and by joining J to P we obtain the shadow of the line PF on the sloping roof, and thus we have the shadow of the entire pole.

Wherever a shadow of a slanting line falls on the roof, it is obtained in this manner; the rays to the V.P.S.R. are shown by dotted lines.

Post MN is vertical, therefore take a line from N to the V.P.S. on the H.L. to touch the wall, continue vertically up the wall to the ridge line, and then continue to the V.P.S. on the roof plane. A ray to the V.P.S.R. determines the length.

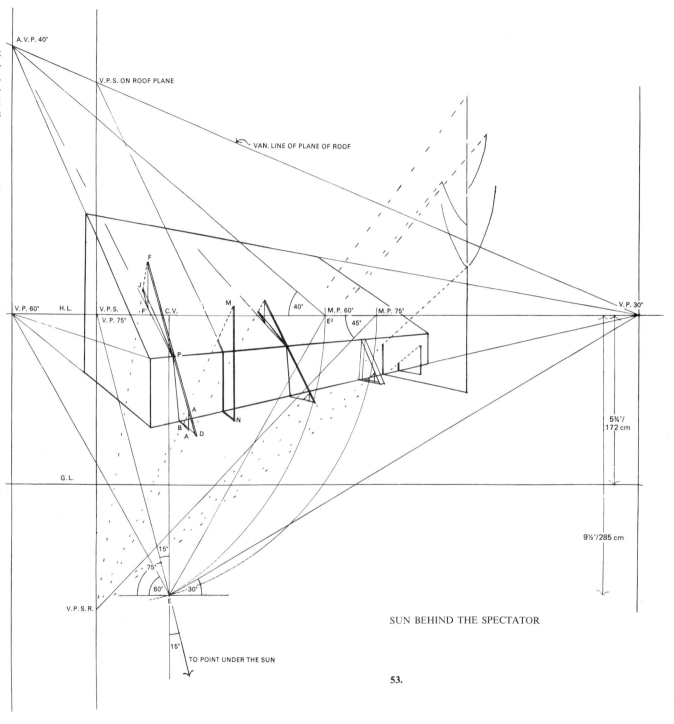

SUN BEHIND THE SPECTATOR

53.

A lift-up page

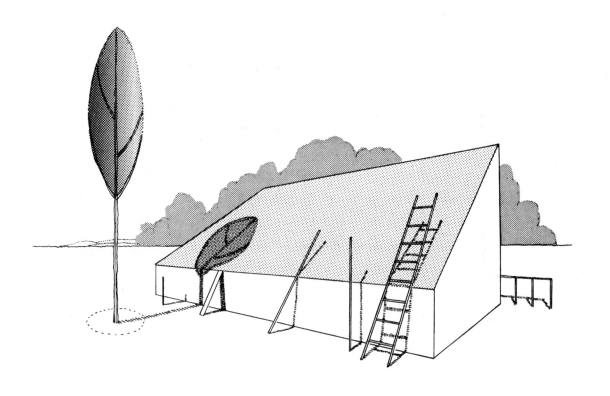

SUN BEHIND THE SPECTATOR

A lift-up page

A ROW OF ARCHES

54. Height of Eye 135 cm (4½ ft).

Distance from P.P. 285 cm (9½ ft).

The Sun is behind the right of the spectator, making an angle of 42° with the P.P. The rays come down at an angle of 45° with the G.P. Therefore the shadows will vanish towards the left at 42°, and the V.P.S.R. will be obtained from the M.P. 42°, and marked below the H.L.

Starting with the vertical edge of the arch AB, take B back towards the V.P.S. until it comes in contact with the far wall of the same arch. Continue up the wall in a straight line until it meets a ray from A to the V.P.S.R. thus finding point A′.

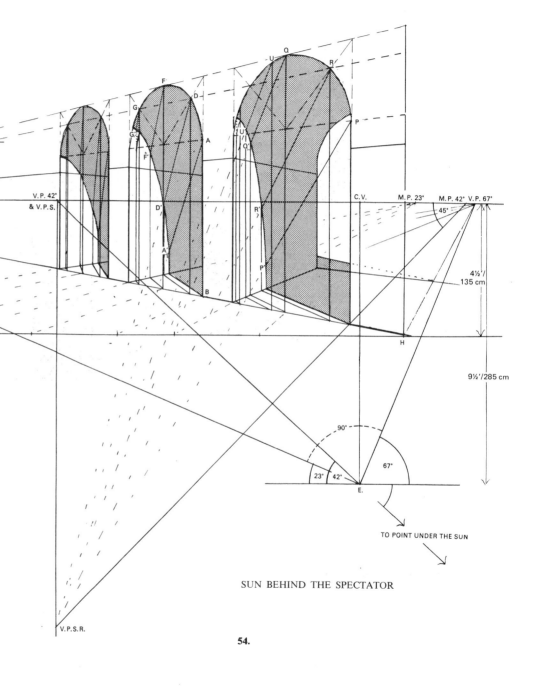

From then on, it will be a curve which is casting the shadow and not a vertical line.

When plotting the shadows of curves, points on the curve casting the shadow are chosen, and from these vertical lines are dropped to touch the ground. The number of points needed varies, a complicated curve needing more chosen points than a simple one.

Continuing the shadow of the centre archway, points D, F and G have been chosen, and verticals dropped to meet the ground immediately below them. Shadows of these verticals are then taken back to meet the wall.

Each one is then taken up the wall, until they meet rays to the V.P.S.R. from their chosen points, i.e. follow the point D down a vertical line to the ground, back to the V.P.S. till it meets the wall, then up the wall vertically to meet the ray from D to the V.P.S.R. at D′.

Similarly with point F.

Now follow point G down to the ground, back to meet the wall, then up the wall to meet the ray. Just before it does this, the surface of the wall receiving the shadow begins to curve, therefore do not continue vertically as shown by the dotted line, but follow the curve of the wall as shown in the diagram.

So where a shadow meets a vertical plane, the shadow is taken up that plane, but where it meets a curve, it is taken round in the direction of the curved surface.

SUN BEHIND THE SPECTATOR

54.

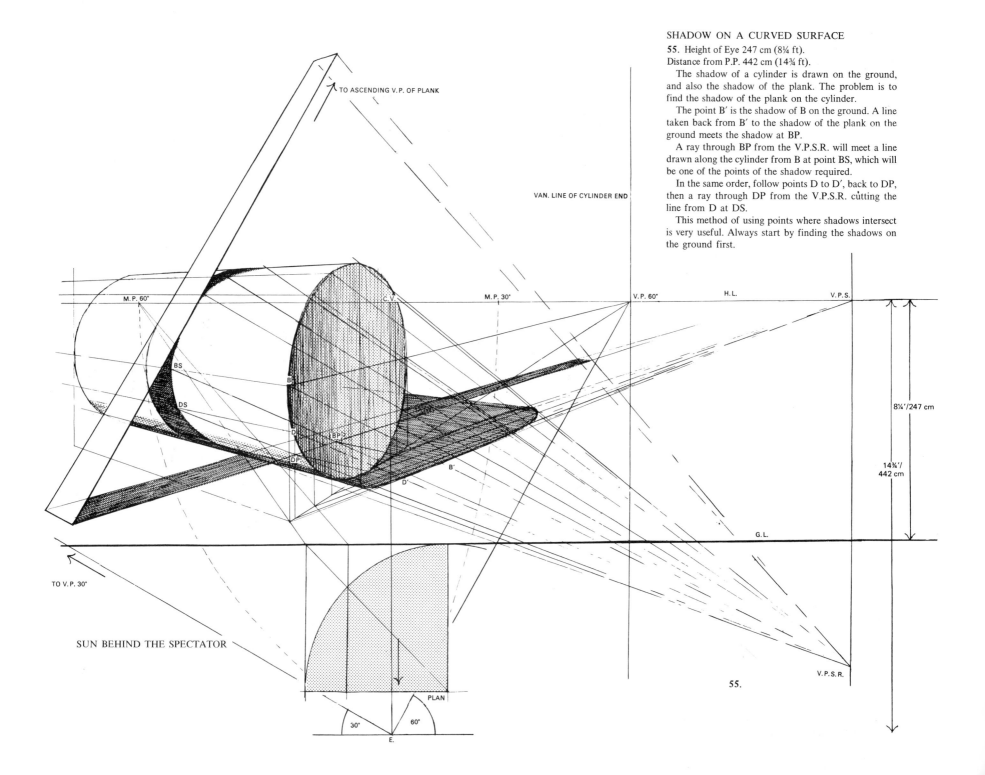

SHADOW ON A CURVED SURFACE

55. Height of Eye 247 cm (8¼ ft).
Distance from P.P. 442 cm (14¾ ft).

The shadow of a cylinder is drawn on the ground, and also the shadow of the plank. The problem is to find the shadow of the plank on the cylinder.

The point B′ is the shadow of B on the ground. A line taken back from B′ to the shadow of the plank on the ground meets the shadow at BP.

A ray through BP from the V.P.S.R. will meet a line drawn along the cylinder from B at point BS, which will be one of the points of the shadow required.

In the same order, follow points D to D′, back to DP, then a ray through DP from the V.P.S.R. cutting the line from D at DS.

This method of using points where shadows intersect is very useful. Always start by finding the shadows on the ground first.

TO ASCENDING V.P. OF PLANK

VAN. LINE OF CYLINDER END

M.P. 60°

C.V.

M.P. 30°

V.P. 60°

H.L.

V.P.S.

BS

B

DS

D

BP

DP

B′

D′

8¼'/247 cm

14¾'/442 cm

G.L.

TO V.P. 30°

SUN BEHIND THE SPECTATOR

V.P.S.R.

55.

PLAN

30° 60°

E.

ARTIFICIAL LIGHT

When shadows are thrown from any kind of artificial light, a point can be found on the Ground Plane immediately under the source of light, and it is from this point that the shadows will *radiate*.

A ray taken down from the light itself will determine the length of the shadow.

Each vertical line is taken separately, and its shadow cast by taking a directional line from a point on the ground under the light through the base of the object, and a ray from the light through the tip of the line casting the shadow. Where the two lines cross is the required point.

Should the shadow of a vertical line meet a vertical surface, then continue the shadow up the surface until it meets the ray cutting off its length.

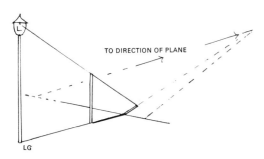

Should it meet a sloping surface, then continue the shadow up the direction of the slope.

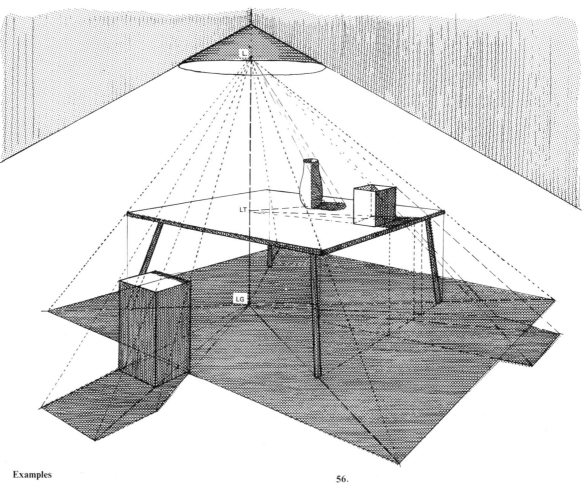

56.

Examples

A SIMPLE INTERIOR

56. An interior is drawn showing how this rule is applied. The point L is the source of LIGHT, LG is the point under the light on the ground, and LT is the point under the light on the table.

Where the shadow of the table intersects the stool, a dotted line has been taken up to the stool top, and then taken along parallel to the table shadow on the ground, i.e. to the same Vanishing Point.

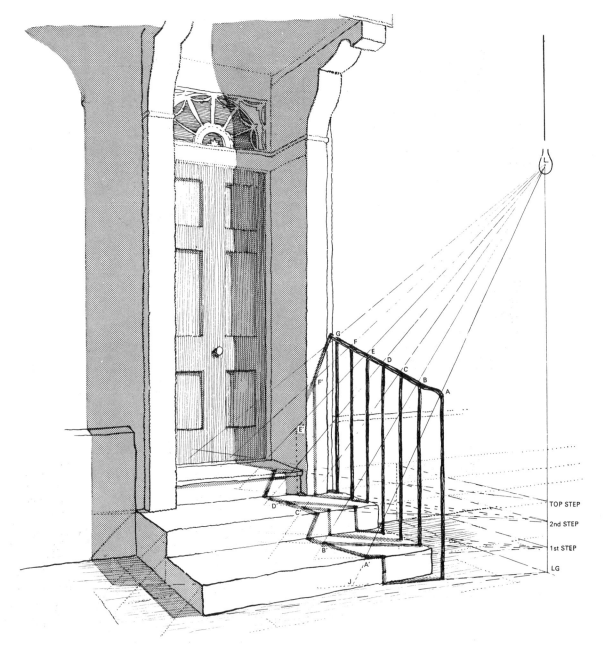

A DOORWAY LIT BY ARTIFICIAL LIGHT

57. The light has been placed rather low in order that the shadows will appear long, and therefore more easy to understand.

A vertical line is drawn down to touch the ground immediately under the suspended light.

The direction of the shadows of vertical lines will radiate from this point LG, where they meet vertical surfaces the shadow line will continue vertically.

Follow the shadow of the first rail A along the ground from LG, until it meets the bottom of the first step, then go vertically up the step, and then along the surface of the first step.

This line along the surface of the first step will proceed from a point the height of the first step above LG and not from LG on the ground. Therefore the height of each step must be marked above the point LG, and this is done by bringing the heights forward: in this case the dotted lines along the wall of the house.

A ray from L through A and produced will meet the shadow line along the surface of the first step at A′, thus giving the shadow of the first railing.

The shadows of the railings B, C and D will also radiate from under the light at the height of the first step. B′ is found by taking a ray down through B to meet the shadow from the base of B.

Take C and D up the vertical front of the second step, and radiate their shadows along the surface of the second step from its height above LG. Mark off the tops of their shadows by rays from L.

When the shadow of each railing-top has been found, the extremities are joined together to give the hand-rail. Eventually the shadow is taken back to the point on the wall where the hand-rail starts.

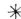

57.

THE CONE OF RAYS

A great deal of thought must be given when starting a drawing. Not only its position on the paper but also your own position must be considered.

When once the C.V. has been decided, one should not include objects which are far to the left or right for these may come outside the line of vision.

The Cone of Rays must be taken into account otherwise the centre of the drawing will appear natural, and the objects at the edge will appear distorted.

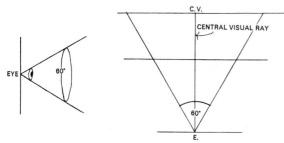

An angle of 60° is considered to be the *maximum* angle within which objects which are to be drawn must lie. This means that the spectator must be at least one and a half times the height away from the tallest building he wishes to draw.

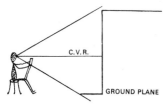

It can be seen from this diagram that only a small portion of the foreground actually comes within the Cone of Rays.

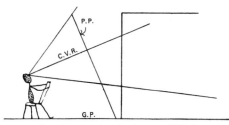

Naturally, when drawing details, one will look up and down, and alter the focus of one's eyes, but as soon as you draw with your head tipped back, the Picture Plane makes an angle with the ground similar to the tilt of your head.

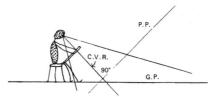

The same applies when you look downwards. The C.V.R., i.e. the Central Visual Ray, continues to be at right-angles in both positions.

However, often there is some simple method by which complicated problems may be solved.

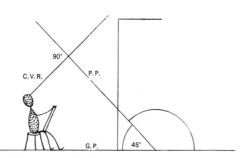

For instance, the Picture Plane could be the fixed plane, and the Ground Plane regarded as a Descending Plane when your head is tipped backwards.

From the side it would look like this,

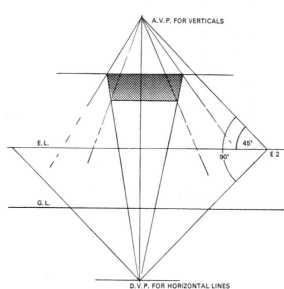

and from the front like this.

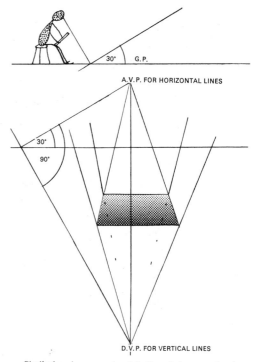

Similarly when your head is tipped downwards, the Ground Plane becomes an Ascending Plane.

If you looked directly above your head, or directly downwards, it simply means that lines which were vertical when you looked straight ahead, now go to the C.V., and the horizontal lines become the verticals.

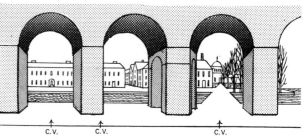

Discretion must be used when doing a panorama, for here one will be moving one's head from left to right, and vice versa, and the Centre of Vision must be moved along the paper to a new position in order to achieve the desired effect.

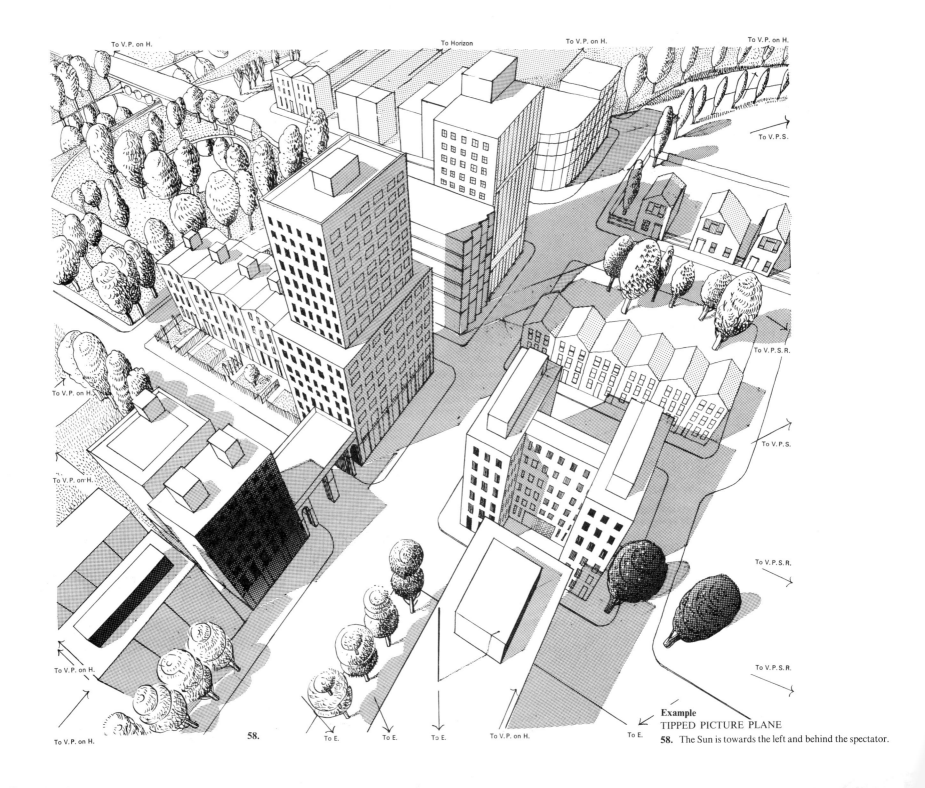

To V.P. on H.

To Horizon

To V.P. on H.

To V.P. on H.

To V.P.S.

To V.P.S.R.

To V.P. on H.

To V.P.S.

To V.P. on H.

To V.P.S.R.

To V.P. on H.

To V.P.S.R.

To V.P. on H.

To E.

To E.

To E.

To V.P. on H.

To E.

58.

Example
TIPPED PICTURE PLANE

58. The Sun is towards the left and behind the spectator.

REFLECTIONS

Examples.

A REFLECTION DRAWN BY
ORTHOGRAPHIC PROJECTION

59. Height of Eye 142 cm (4¾ ft).
Distance from P.P. 255 cm (8½ ft).

For this method, as in all orthographic projection, the plan is placed in its position above the Horizon Line. The point A being 90 cm (3 ft) to the right of the spectator, and 90 cm (3 ft) beyond the Picture Plane.

As the angle of incidence equals the angle of reflection, the plan of the reflection has also been drawn as shown in the diagram.

The problem is to put the rectangle, mirror and reflection in perspective.

Draw the basic diagram in the usual manner, finding the V.P.'s and point A, here marked as A^2.

Lines are drawn from all the corners of the rectangle on plan and the reflection on plan towards E. Where these lines cut the H.L. verticals are dropped and taken down towards the G.P.

The line from A passes through A′ and down to A^2, and horizontal lines are drawn across to meet the verticals, and others taken back to the C.V.

A line from A^2 taken across to the mirror edge cuts it at P^2, and is then taken back to the V.P. 60°. By using the verticals and the V.P.'s all the points are found for the perspective drawing.

Reflections in mirrors are something which you may rarely need. Often it is quicker to have an actual mirror and place the object where you wish. For one thing it can be moved about until the exact view required is obtained.

An india-rubber placed in front of a pocket mirror will give you something of the result you expect to get.

Here the reflection has been drawn by using orthographic projection, and by holding the page towards the light, the perspective method is compared.

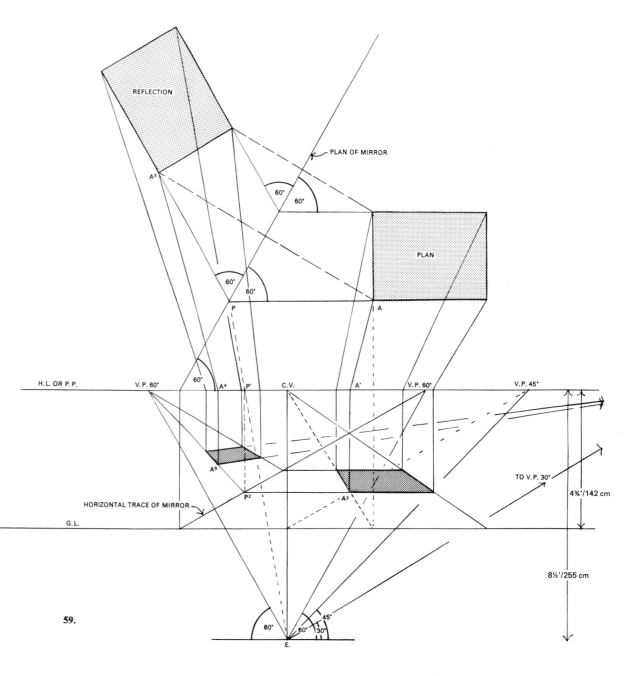

59.

DRAWING REFLECTIONS IN MIRRORS BY PERSPECTIVE

60. Height of Eye 142 cm (4¾ ft).
Distance from P.P. 255 cm (8½ ft).

The 90 cm × 120 cm (3 ft × 4 ft) rectangle lies on the G.P. with the near corner 90 cm (3 ft) to the left of spectator, and 90 cm (3 ft) beyond the P.P.

A vertical mirror touches the P.P. at a point 112.5 cm (3¾ ft) to the right, and vanishes towards the left at 60°.

First draw the mirror trace and the rectangle by means of perspective in the usual way. The angle of incidence is 60°, therefore the reflecting angle will also be 60°.

The sides of the rectangle which are parallel to the P.P. are produced to touch the mirror, and then continued towards the V.P. 60°, beyond the mirror.

Using the M.P. 60°, measure the distance AP on plan, along the G.L. to the right from Q. Take this distance back to the M.P. 60° thus making AP equal to PB. The reflection is drawn in by using the V.P. 30°.

If in doubt, draw a small plan first, and from this the reflecting angle may be determined.

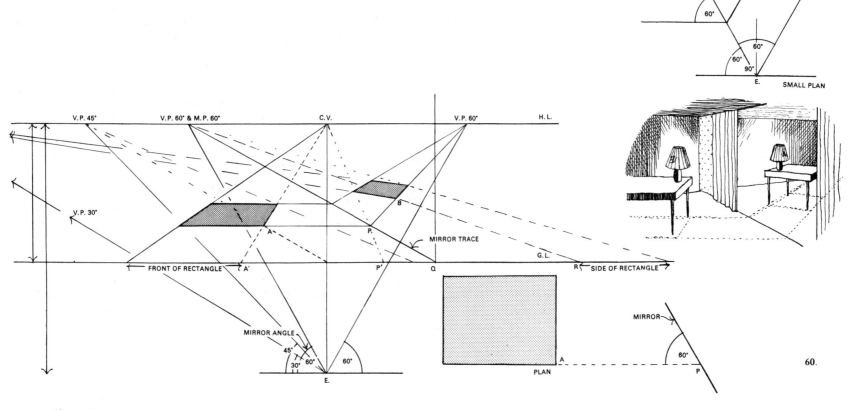

SMALL PLAN

PLAN

MIRROR

60.

A TIPPED OBJECT TO BE REFLECTED
IN A MIRROR

61. Height of Eye 180 cm (6 ft).
Distance from P.P. 277 cm (9¼ ft).

The diagram shows a cube with one edge touching the G.P. and vanishing towards the right at 30°. The front faces ascend and descend to the A.V.P. 45° and D.V.P. 45° respectively.

The reflection of this cube is seen by holding this page towards the light.

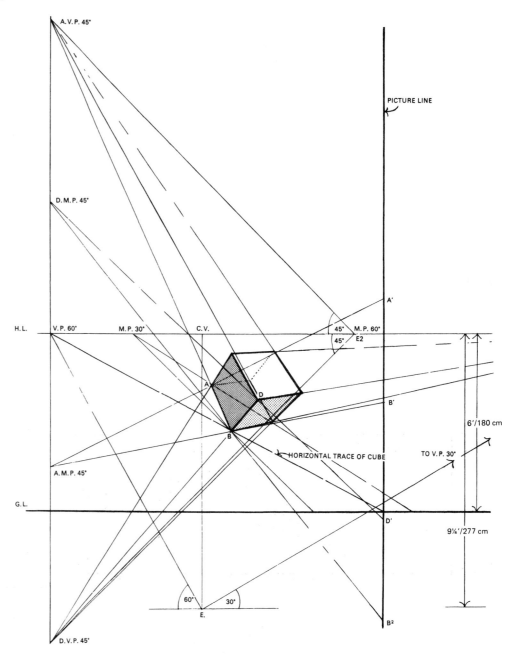

61.

REFLECTION OF TIPPED OBJECT IN VERTICAL MIRROR

The Horizontal Trace of the mirror edge recedes towards the left at 50°. The vertical face of the cube lies in a plane which vanishes towards the right at 60°.

Therefore by drawing a small plan we find that the angle of incidence is 70°. (60+50+70=180)

By making the angle of reflection equal to 70° on the small plan, and by drawing a line parallel to the P.P., we find that the reflecting line brought forward to the P.P. makes an angle of 20°. Therefore the vertical face of the cube to be reflected will be in a plane at 20° to the P.P.

Vanish towards the V.P. 20° at the point of contact with the mirror. Shown on the diagram where the angles of 70° are marked in perspective on the G.P.

The cube can now be drawn by using the M.P. 20° in the usual manner.

A lift-up page

A SQUARE REFLECTED IN A TIPPED MIRROR

62. Height of Eye 157 cm (5¼ ft).

Distance from P.P. 240 cm (8 ft).

The mirror is tipped forward at 45°, and the Horizontal Trace goes towards the right at 45°.

The near corner of the 120 cm (4 ft) square is 60 cm (2 ft) to the left of the spectator, and 60 cm (2 ft) beyond the P.P.

Draw the square in parallel perspective in the usual manner, and lying 67 cm (2¼ ft) in front of the mirror on the G.P.

Construct the mirror by using Oblique perspective.

In order to visualize the position of the reflection you intend to draw, make a small sketch plan, and also an elevation, and on these mark the angles and indicate one side of the square.

By drawing up to the mirror on the small side elevation, and by making the angle of incidence equal to the angle of reflection, and also the distances equal, it will be seen that because the mirror slopes up at 45°, the reflection of the square will lie in a vertical plane, i.e. at 90°, because 45+45=90.

On the large diagram, take the square back towards the V.P. 45° on the left to meet the mirror's edge. Using the D.V.P. of the mirror, produce lines upwards from these points of contact, thus making angles of 45° with the Ground Plane and the mirror's edge.

Because the square's reflection lies in a vertical plane, it will be quite easy to draw in the usual manner, forgetting, for the moment, that the mirror is there.

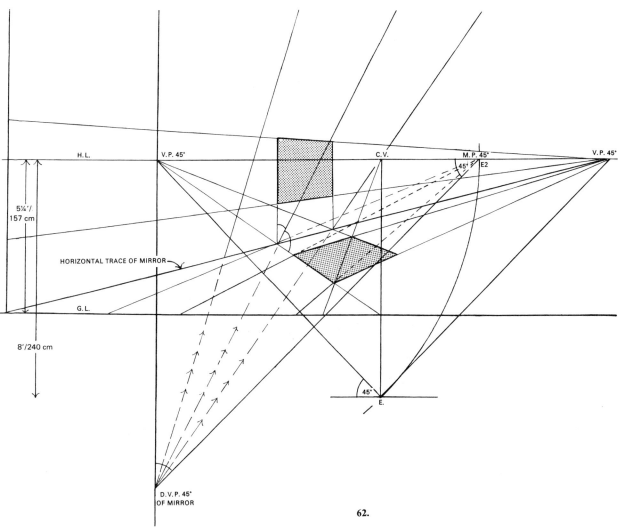

62.

SMALL PLAN ELEVATION

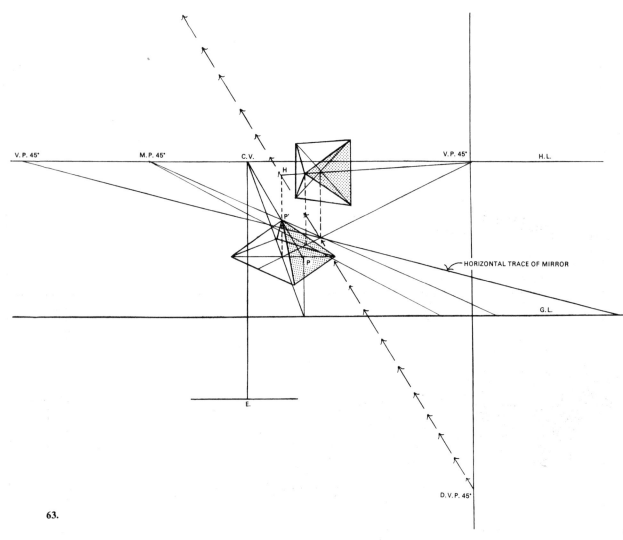

V.P. 45° M.P. 45° C.V. V.P. 45° H.L.

H

P'

P

HORIZONTAL TRACE OF MIRROR

G.L.

E.

D.V.P. 45°

63.

THE REFLECTION OF A PYRAMID

63. This 60 cm (2 ft) high pyramid has been constructed by using the square on the reverse side of this sheet as a base. Both can be seen together by holding the page towards the light.

The height of the pyramid was erected on a line taken up through the centre of the square and the corners joined to it.

A line through the centre of the square taken back to the horizontal V.P. 45° gives the point of contact with the mirror.

A line up from the D.V.P. 45° through this point is now produced upwards, shown in the diagram by an arrow-dotted line.

A vertical line drawn up through the pyramid will contact the mirror at point H on the arrowed line, and at this point a line back to the horizontal V.P. 45° will give the corresponding line on which will lie the reflection of the top of the pyramid.

Distances along this line can be measured by taking verticals up from the G.P. as this line is horizontal with the G.P. These distances are necessary in order to find the apex of the pyramid, and its distance beyond the surface of the mirror.

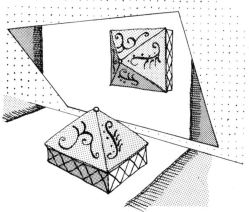

REFLECTION IN A MIRROR TIPPED FORWARDS

64. Height of Eye 32 cm (12½ in.).
Distance from P.P. 58 cm (23 in.).

The mirror is tipped forward at 25° with the G.P., the direction being 60° to the left.

The side of the box AB is 30 cm (12 in.) long, AB vanishes towards the V.P. 30° on the right, and lies 40 cm (16 in.) in front of the mirror and parallel with it.

The angle of incidence + the angle of reflection = 50°, therefore the reflection of the box will vanish towards the D.V.P. 50°. Lengths of the box will be measured from the D.M.P. 50°, using the Picture Line erected at the G.L. where the V.P. 30° produced through BA, touches it at Q.

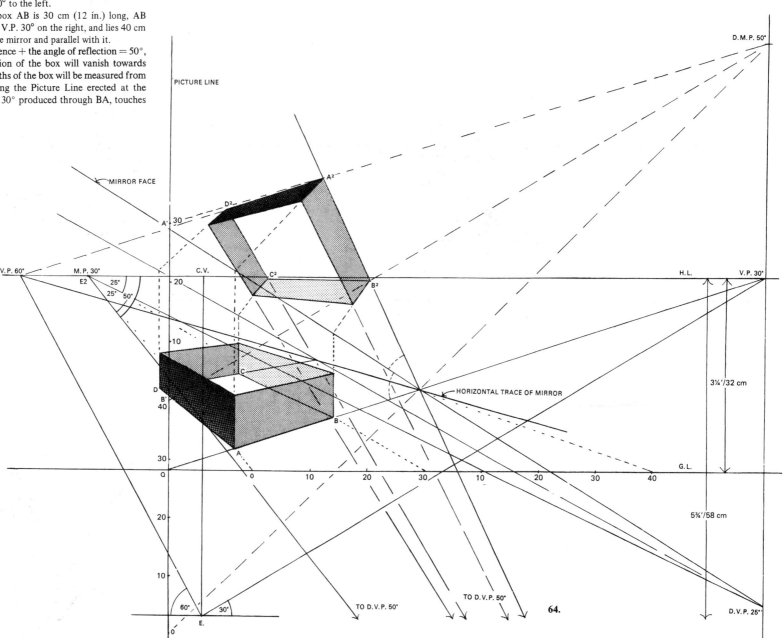

79

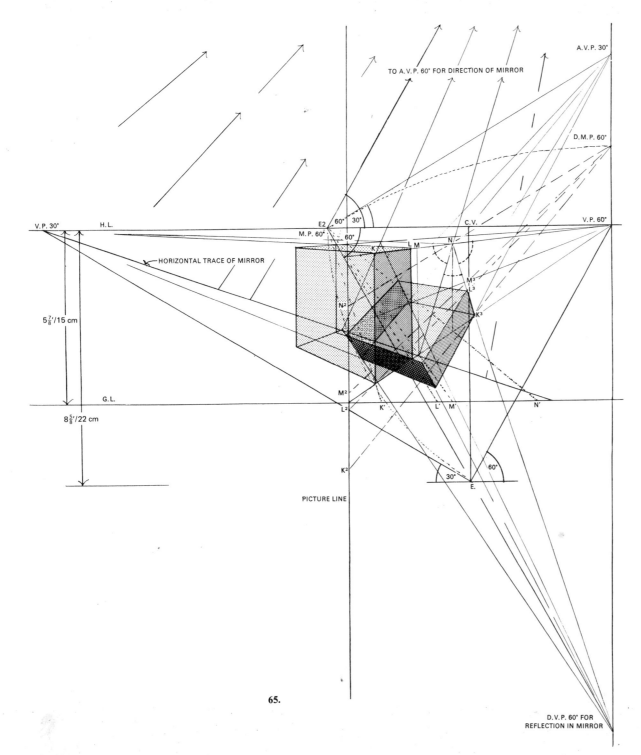

REFLECTION IN A MIRROR TIPPED BACKWARDS

65. Height of Eye 15 cm ($5\frac{7}{8}$ in.).

Distance from P.P. 22 cm ($8\frac{5}{8}$ in.).

The horizontal trace of this mirror is at 30° towards the left, and the angle at which it is tipped is 60°.

Therefore the M.P. 60° is used as E2, for measuring the ascending and descending angles.

The rectangular shape to be reflected is produced to contact the mirror edge at the Horizontal Trace. Lines will be taken towards the V.P. 60°. Where they contact the mirror, they are taken up towards the A.V.P. for the face of the mirror.

The top rectangle is produced in a horizontal plane also, to contact the mirror at these ascending lines.

For instance, follow the line KL which contacts the mirror at N, making an angle of 60°.

Because the angle of incidence is 60°, and the reflection angle the same, the angle at which we shall descend will be 60°+60° from 180°, which is also 60°. This 60° will be marked at the M.P. 60° and taken down for the D.V.P. 60°.

A line from N to this D.V.P. will give the direction in which the points K and L reflected, will lie.

Bring N forward from the D.M.P. to meet the vertical Picture Line at N², and mark off distances N², M², L², and K².

These distances are obtained from the G.L. where they have been produced forward as shown by dotted lines.

From these points N²M²L²K² return to the D.M.P. here shown by dashed lines, thus cutting the line from N to the D.V.P. at points M³, L³, K³.

L³K³ is the reflection of LK, and the rest of the reflection can be drawn in.

65.